IMAGES
of America

RODEO

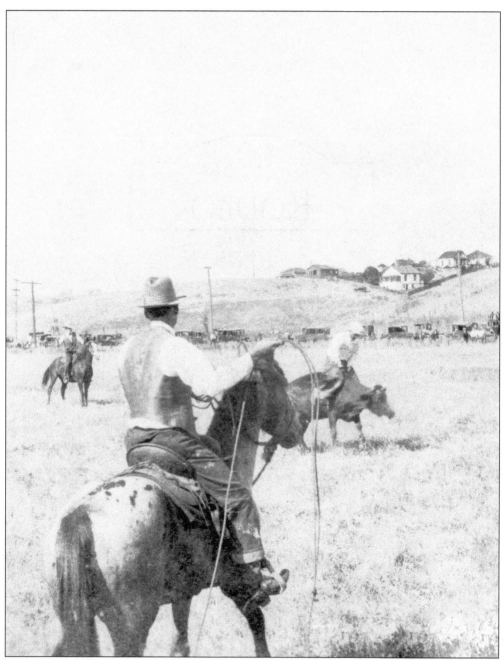

RODEO CONTEST, JULY 1927. The town held a rodeo on July 24, 1927, near the present-day Lefty Gomez Field. The rider in the leather vest while watching the action faces east toward houses located on Fourth Street Hill. Automobiles are parked along Parker Avenue–State Highway 40. Rodeo was then surrounded by grassy hills where cattle grazed. (Courtesy Thompson family.)

ON THE COVER: The same field as shown above is the site of a Rodeo Boosters Club event 20 years later. Horse trainer Steve Bonovich strides toward his wife, Leona, in the buggy, while ranch foreman Lloyd Radar acts as emcee. (Courtesy of Velma Dowling.)

IMAGES
of America

RODEO

Jennifer Dowling

ARCADIA
PUBLISHING

Published by Arcadia Publishing
Charleston SC, Chicago IL, Portsmouth NH, San Francisco CA

Library of Congress Catalog Card Number: 2006941042

For all general information contact Arcadia Publishing at:
Telephone 843-853-2070
Fax 843-853-0044
E-mail sales@arcadiapublishing.com
For customer service and orders:
Toll-Free 1-888-313-2665

Visit us on the Internet at www.arcadiapublishing.com

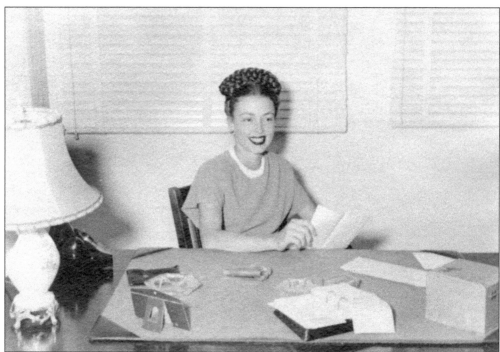

VELMA DOWLING, WRITER AND TEACHER. In 1948, the author's mother, the late Velma MacArthur Dowling, sits at her *Tri-City News* desk. She wrote the local news column "Round-Up" under the byline of "Mac," as well as feature articles on the history of Rodeo and its people. Velma inspired this book and passed on a love of history, as well as clippings, interview notes, books, and photographs that were valuable resources in compiling the town's story. She and Dr. Ruth Carlson worked with students on historical research projects, including "100th Anniversary of Rodeo School District," (*Tri-City News*, 1964), *Learning is Our Life* (1959–1960), and *Round-Up of Rodeo History* (1954), the latter now in the collection of the University of California Bancroft Library.

CONTENTS

ACKNOWLEDGMENTS

This pictorial history was made possible by Robert G. Bonovich, whose archive of early Rodeo photographs and written history formed the core of the book. He preserved rare images from the collections of the late Harry Nancett, Josephine (Claeys) Valerro, Annie L. Fernandez, and Edward Werth. Sue Thompson Harryman enthusiastically supported this book, made suggestions on the layout, and contributed photographs taken in the 1920s by her father, Joseph Thompson. Frank Silva and Jim Silva made telephone calls to locate materials and gathered a group to talk about the book. Edward Sacca supplied pictures from his family albums and helped to identify people in photographs. The Rodeo-Hercules Fire Protection District, the Crockett Historical Society, and the California History Section of the California State Library generously made their archives available. Uncredited photographs come from the collection of the author's mother, Velma Dowling. Many thanks also go to those who provided photographs and information: Diane Adame at St. Patrick School, Judy and Frankie Adams, Mel Bailey, Rae Blackwood, Dick Boyer, Jim Brownlee, Dave Bunyard, Charise Ceballos, David Claeys, the Homer Colvin family, the Contra Costa History Center, the Contra Costa Fire Protection District, Art Cooper, Rev. L. L. Davis, Mal Decker, Shirley Johnson, Janet de Lara, David George, Jerry Ginochio, John Harder, Rich Hemenez, Emily Hopkins, Jerry Johnson, Lester Kinsolving, Arlene Krager, Gordon Lavering, Elaine Lindner, Anita Mann, Scott McQuarrie, Mary Mello, Marsha Molinaro, Tito Moreno, Alan Mower, the Orsi family, Charles Posedel, George "Lefty" Serpa, Nowell MacArthur, Marlene Nancett, John and Mary Pereira, Kerry Creed Perez, Marcia MacArthur Raborn, Aart J. Rackwitz, Raymond L. Raineri, Newell Schandelmier, Diva Silva, Sheri Silva, and Karen Werth. Finally, thank you to the students in the Round-Up Club who interviewed many longtime residents in 1954 about the history of the town.

INTRODUCTION

Rodeo lies within the historic Spanish land grant called El Rancho de Pinole, owned by Don Ignacio Martinez, the former *comandante* of the pueblo of San Francisco. In 1865, Irish-born brothers John and Patrick Tormey purchased 7,000 acres of land from the Martinez heirs. The brothers divided their lands, with Patrick taking the portion encompassing what came to be known as Rodeo. In 1890, Patrick sold 1,500 acres to the Union Stock Yard Company, which planned a large meat-canning facility. The company erected stockyards, a slaughterhouse, smokehouses, and a meatpacking plant and subdivided the rest of the land into lots for stores and homes. Unfortunately for the investors, a financial panic occurred in 1893, accompanied by several years of worldwide business contraction. As a result of the poor economy, which also led to the closure of the Starr flour mills at Crockett, the stockyard was never fully operational. By 1895, the company was declared insolvent and eventually was sold at foreclosure. Rodeo grew slowly, and by 1925, it had a population of only 1,000.

The name Rodeo was borrowed from the place names Rodeo Valley, appearing on a map as early as 1860, and Rodeo Creek, a name that dates from at least 1865. The Spanish word *rodeo* (ro-day´-o) connotes a cattle enclosure at a market and came to mean the rounding up of cattle for taking to market. Today it is a common term for a cowboy contest of skills. On April 8, 1892, a few weeks after the filing of the official town map at the county recorder's office, the Rodeo post office was established.

Industrial development grew in and around Rodeo. Both Western Oil and Plaster Products established plants at the Rodeo waterfront. A powder works located in Pinole and Hercules, a smelter at Selby, and a sugar refinery moved into the former flour mill at Crockett. The California Redwood Company purchased property at a site later known as Oleum where Union Oil built a refinery in 1895; it became a major source of employment for Rodeo residents and is closely identified with the town itself.

During the World War II era, global economic forces again impacted the town's economy. Defense-industry workers thronged to the Bay Area to work in the shipyards, refineries, and other industries that supplied the war effort, causing Rodeo's population to surge between 1940 and 1949, from 2,100 to 7,500. To accommodate many of the new arrivals, the Bayo Vista housing project was built. Retail expansion followed, leading to several prosperous decades for Rodeo.

The opening of U.S. Interstate 80 brought major change again by diverting traffic from the once-busy Route 40 (Parker Avenue), and with that traffic decline, retail trade was affected. As a result of the dip in sales, the downsizing of Bayo Vista in the early 1960s, and a changing social environment, the town's population shrank. When new housing was built south of Interstate 80, the population enjoyed another uptick. Today Rodeo looks forward to a future that includes a rebirth of its downtown, new housing, and a revitalized waterfront.

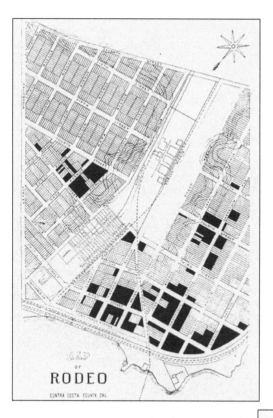

RODEO TOWN SITE MAP. The official map of Rodeo was recorded in April 1892. Street names reflect officers and investors in the Union Stock Yard: Garretson, Sharon, Parker, Harris, Tormey, and Mahoney. The stockyard is in the white area at the center of the map. At bottom left is the three-story Hotel Rodeo, and a plaster of paris plant is on the waterfront.

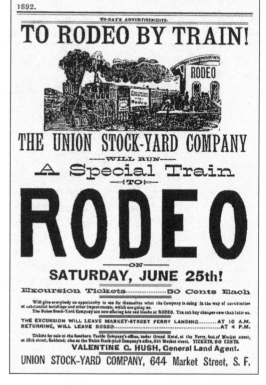

EXCURSION BY TRAIN, 1892. The special train excursion, one of several between 1892 and 1893, was 50¢. One of these events drew 2,000 people who paid a total of $14,000 for 110 lots sold at auction.

One

THE FIRST 50 YEARS

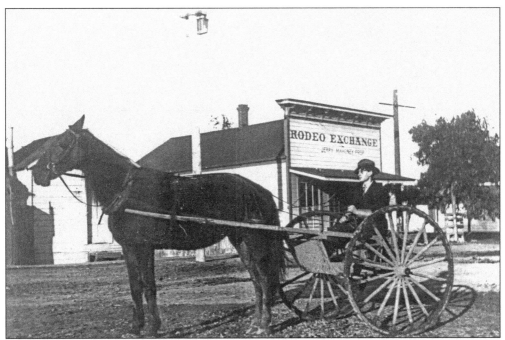

RODEO'S FIRST SALOON. Patrick Tormey's ranch foreman, Jeremiah "Jerry" Mahoney, built and operated Rodeo's first saloon, the Rodeo Exchange. Mahoney, an Irish immigrant, also graded the streets for the new town. It was said he could plow "straight as a gunshot." The early town residents built homes on Lake and Garretson Avenues. Some of these houses remain, but most of the early commercial buildings were destroyed in fires. This chapter covers the first 50 years of the town, from its founding in 1890 to the advent of World War II. (Courtesy Werth family.)

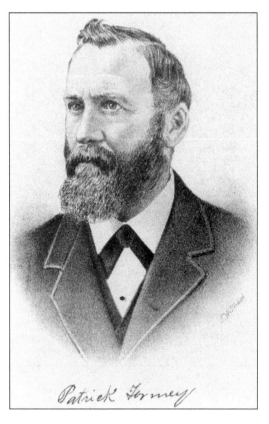

PATRICK TORMEY, EARLY SETTLER. Patrick Tormey, "The Father of a Town," was born in Ireland in 1840 and immigrated to California when he was 18. He and an older brother, John, ultimately acquired property stretching from present-day Pinole to Tormey. Both brothers served as county supervisors, and Patrick was involved in the Union Stock Yard Company, to which he sold the Rodeo town site. His life came to a dramatic end in May 1907, when he died of food poisoning after dining in Oakland, California.

Patrick Tormey

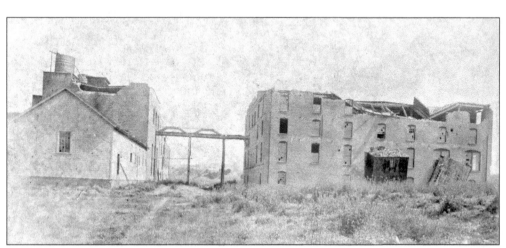

MEATPACKING PLANT, 1906. The ruins of the Union Stock Yard were recorded on April 18, 1906, hours after a major earthquake shook the entire Bay Area. In the 1890s, the facility included seven four-story buildings, two ice plants, railroad track, seven miles of pipe, 54 cattle pens, 72 sheep and hog pens, and a 1,000-foot wharf. Salvaged brick was bought by Grace Brothers Brewing Company for its Santa Rosa brewery. (Courtesy Crockett Historical Society, Harry Nancett Collection.)

TO RODEO BY STEAMER.

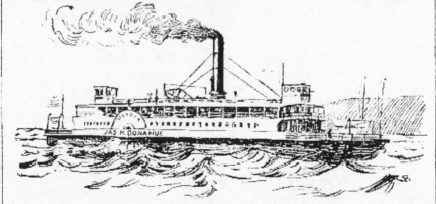

THE STEAMER JAMES M. DONAHUE WILL TAKE THE

Third Grand Excursion to Rodeo

SUNDAY MORNING, JUNE 5th,

Leaving Tiburon Ferry Slip at 9:30 A. M., Returning Leaves Rodeo at 3:30 P. M.

ROUND TRIP TICKETS, 50 CENTS.

This will be a delightful trip; sailing through San Francisco and San Pablo bays, passing Alcatraz Island, Angel Island, Point San Quentin, Red Rock, Two Brothers, Point Pinole, Mare Island and landing at the Union Stock Yard Company's own wharf at Rodeo. It will be an excellent opportunity to inspect Rodeo and its many improvements and to judge of its destiny; of the present and future value of its real estate. Salesmen will be on hand to show the property, which will be found reasonable in price and sure to advance in value rapidly, because Rodeo is certain to be a large town very soon. You will be convinced of this when you see Rodeo. Money is being poured into the town like water and substantial improvements are rising on every side, chief of which are the extensive manufacturing and packing houses of the Union Stock Yard Company, which will give employment to a great number of men.

TICKETS FOR SALE AT THE TIBURON FERRY AND AT THE COMPANY'S OFFICE.

UNION STOCK YARD COMPANY

644 Market Street.

EXCURSION BY STEAMER, 1892. "To Rodeo By Steamer," urging potential buyers to visit a town into which money is being poured, appeared in the *San Francisco Examiner* on June 3, 1892. The trip to Rodeo was a special excursion not on the regular route. The paddle-wheel steamer *James M. Donahue*, named for a pioneer San Francisco industrialist, was put into service to connect the North Bay (Tiburon) to San Francisco. The pride of the Donahue boats was capable of 18 knots.

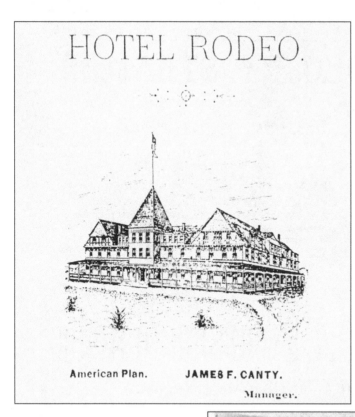

HOTEL RODEO, 1892. The three-story Hotel Rodeo, located at the northwest corner of Vaqueros Avenue and First Street, included offices, a stock exchange, a bank, a bar, vaults, sitting rooms, a dining room, a kitchen, and 43 handsomely furnished guest rooms, plus unfinished space for expansion. It was built for $31,370 by Oakland's Smilie Brothers. By 1893, the stockyard had failed, and the hotel was later closed. On a Sunday evening in March 1897, a fire consumed the structure.

LAGRAND HOTEL. The LaGrand Hotel and Bar (previously known as the Depot Hotel), opposite the Southern Pacific station on San Pablo Avenue, was constructed in the 1890s. The bar is remembered as the site of a fatal shooting in which a packing-plant butcher attacked his own brother, whose affectionate attention to the butcher's wife had made him jealous. The bar was destroyed by a fire after the building had been vacant for several years. (Courtesy Marlene Nancett.)

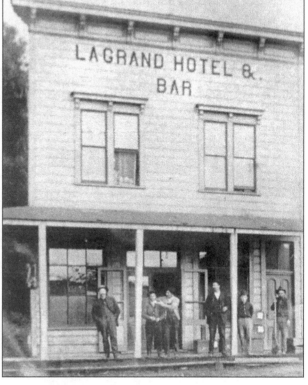

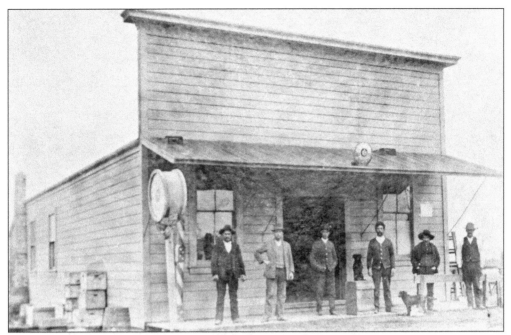

CARDOZA'S SALOON, 1906. Antone "Tony" Cardoza's saloon, at 642 First Street near Railroad Avenue, was photographed the morning after it opened. Tony was one of several brothers who came from Portugal, an immigrant group heavily represented in early Rodeo. Note the barber pole at left. Ruhstallers Steam Beer is advertised on the circular sign. (Courtesy Marlene Nancett.)

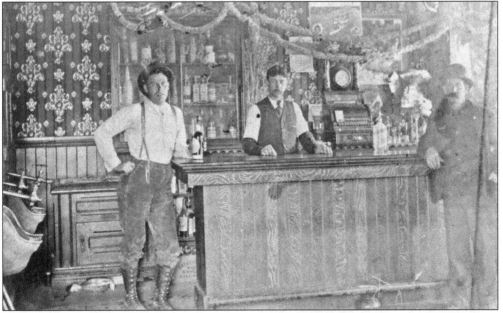

MAHONEY'S SALOON. This early-20th-century view shows Jerry Mahoney behind the bar. The men are believed to be Bill Pawsey (left), a teamster, and John Cooper (right), an oil company worker. Buckets could be filled with beer at the taps on the left, while the more expensive whiskeys sit on shelves behind doors etched with the words "Old Judge Whiskey." The saloon was one of eight buildings that were destroyed in a July 1915 fire. (Courtesy Ginochio family.)

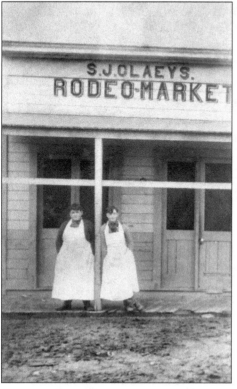

SEBASTIAN "S. J." CLAEYS. S. J. Claeys stands outside his butcher shop on the south side of First Street, then Rodeo's main street. The Michigan-born butcher wrote: "On January 7, 1907, I came to Rodeo and took over the meat market then owned by Jerry Mahoney. I paid him $250 for the business and he allowed me two months free rent." Claeys went on to establish the Rodeo waterworks, was president of the trustees of the Rodeo School District, helped organize the First National Bank of Rodeo and the chamber of commerce, and was a principal in the Rodeo Townsite Company, some of the activities that earned him the name "Mr. Rodeo." In the photograph below, two unidentified employees pose outside the market. In May 1927, Claeys moved into a new brick building that survives at 525 First Street. (Above courtesy Werth family; below courtesy Jim Brownlee.)

PAGANINI'S STORE, 1905.
A. Paganini's Rodeo fruit
and vegetable store was
located at 526 First Street,
across from the Rodeo
Meat Market. The sign
in the window is for the
United Ancient Order of
Druids' annual Christmas
party. The store burned
in a large fire on July 12,
1915, that also claimed
Dr. Manuel L. Fernandez's
office, Lehman Brothers
general merchandise on
First Street, Frank Lopez's
saloon and barber shop,
and several other stores.
(Courtesy Werth family.)

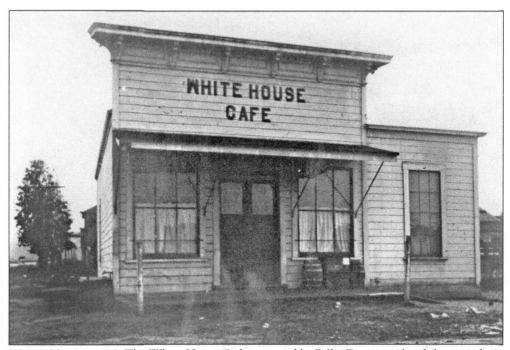

WHITE HOUSE CAFÉ. The White House Café, operated by Billie Drennan, faced the waterfront along San Pablo Avenue near the curve at Parker Avenue. Wood commercial buildings such as this, which were so vulnerable to fire, were mostly replaced by brick structures in the mid- to late 1920s. (Courtesy Werth family.)

JOHN QUILL'S HOTEL. The Bay City Hotel, originally called Quill's, still stands at the junction of Pacific and Rodeo Avenues, although it is now an apartment house. Subsequent updates include stucco on the exterior walls and removal of the rooftop dormers.

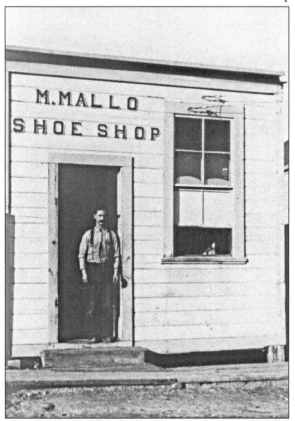

M. MALLO, COBBLER. The apparent misspelling on Manuel Mello's sign is a mystery. The successor to the Mallo business was C&D Shoe Shop, operated by Cesar Dias and son at 526 First Street. (Courtesy Werth family.)

BEAUTY SHOPPE. One of the tenants in this storefront at the southwest corner of Rodeo Avenue and First Street was Frankie Byrone. In 1949, she offered a French razor wet cut with free shampoo for $1.25. Some of the other salons operating in Rodeo over the years are: Margie's and Manuel's on Second Street, Tiki Coiffures on Harris Street, Wanda's at various locations, and Laura's Beauty Salon on Railroad Avenue. This Victorian-era store has long since been demolished, and a single-family house is now at this corner.

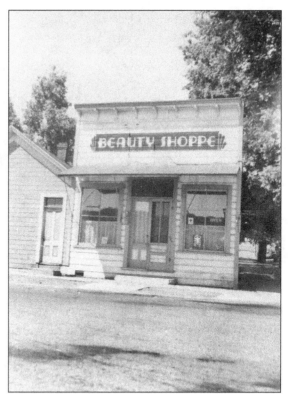

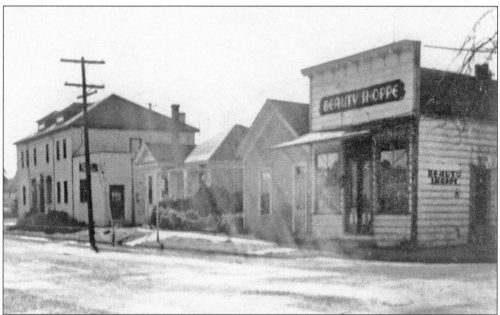

RODEO AVENUE. This streetscape looks south along Rodeo Avenue from the intersection with First Street. The Bay City Hotel is at left, and the Beauty Shoppe is at right. The hotel-apartment is the only survivor among these buildings. The little building to the right of the hotel, which served at various times as a bar, a gym, and a banquet hall, has since been incorporated into the residential living quarters. (Courtesy Ginochio family.)

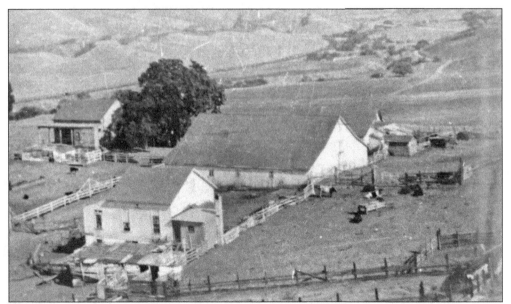

FERNANDEZ RANCH. Carroll and Annie L. Fernandez and their nine children lived in the beautiful Rodeo Valley between Rodeo and Franklin Canyon. The ranch was located near the present-day Franklin Canyon golf course. The Rodeo Valley School was also located on this property. Today Rodeo Valley is bisected by Highway 4 and is also occupied by a petrochemical plant and a truck yard. (Courtesy Annie L. Fernandez.)

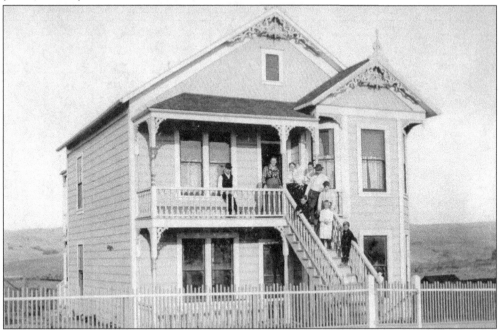

SLATE HOME, 381 GARRETSON AVENUE. This is the first home in Rodeo occupied by John and Ellen Slate, whose family stands on the steps. John Slate was employed at the smelter at Selby but was also a capable carpenter. Following the loss of this house to a fire, John built a replacement house plus several others with the help of Joe Johnson, seen standing on the porch beside a neighbor, Ellen Cooper. (Courtesy Gordon Lavering.)

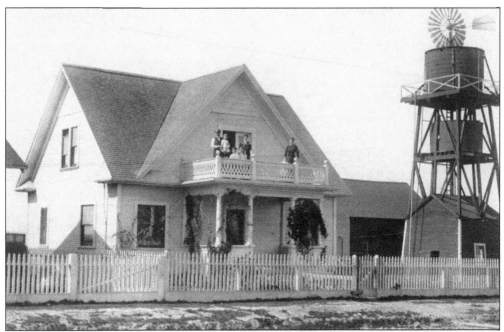

CLAEYS HOME, 416 GARRETSON AVENUE. This is the second Claeys family home in Rodeo, completed in January 1912, after a big fire on October 12, 1911, rendered the family and 15 others homeless and destroyed Johnson's town hall at Second Street and Garretson Avenue. The fire was started when Ruth Hughes overturned a kerosene lamp. Residents pulled much of the furniture to safety, but were unable to save the houses due to a lack of water. (Courtesy Valerro family.)

JOHN AND ELLEN COOPER HOUSE. The handsome Queen Anne–style house with twin angled-bay windows, decorative trim in the gable ends, and rooftop finials was on Garretson Avenue. John Cooper, a native of Wales, worked at the oil refinery. (Courtesy Gordon Lavering.)

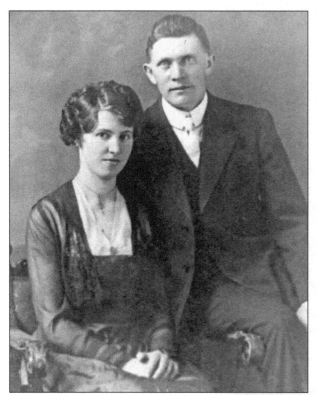

DOWLING FAMILY, 1919. Jennie and Denis Dowling pose for a wedding portrait that was sent to relatives in Ireland. The couple met in San Francisco following Denis's return from military service in France. He became a stillman at Union Oil Company, and Jennie brought up their five children in their home at Second Street and Rodeo Avenue, where they had chicken coops, a vegetable garden, and a small orchard.

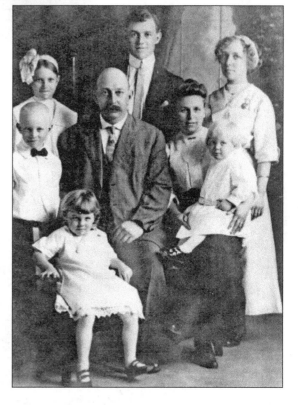

SLATE FAMILY, 1912. John and Ellen "Nellie" Slate emigrated from England and married in San Francisco in 1889. Seen here in 1912 are, starting clockwise from the little girl in the rocking chair, Dorothy, Harold "Baldy," Ellen, William, Alice, Roy, and parents John and Nellie. Thirteen-year-old James was killed in a tragic hunting accident at Selby the previous year. (Courtesy Gordon Lavering.)

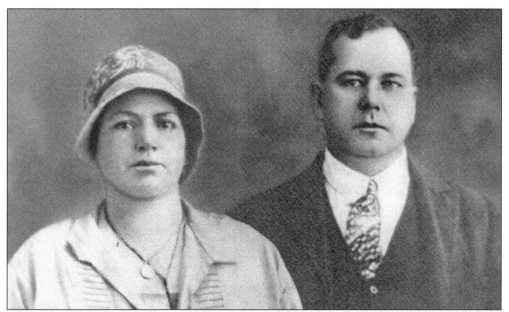

PACHECO FAMILY, 1920S. Anthony and Maria Benedita (née Morias) Pacheco emigrated from Portugal. Accompanied by his brother, Anthony arrived first, but the two were unable to bring their wives to this country until World War I ended. The first child of both couples was born in Portugal. Anthony and Maria had seven other children in the United States and established a tomato farm at Seventh Street and Napa Avenue. (Courtesy Frankie and Judy Adams.)

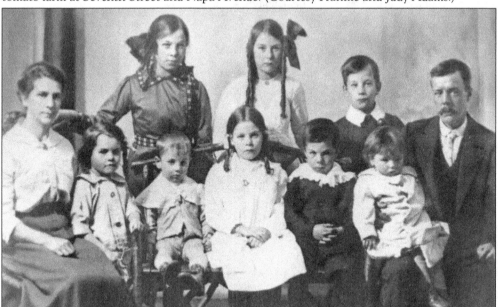

THOMPSON FAMILY, 1915. The Thompson family posed for this passport photograph when they came to Rodeo from Manchester, England, in 1915. From left to right are (first row) Elizabeth, Ethel, Alec, Nellie, John, and Harold; (second row) Emma, Alice, Joseph, and Alexander. Not included is daughter Minnie, who arrived three years earlier. Minnie and Emma worked for the sugar refinery in Crockett, Alexander "Scotty" was an oil refinery boilermaker, and Elizabeth took in wash. (Courtesy Thompson family.)

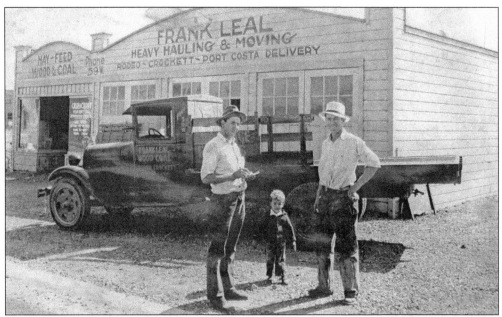

LEAL'S FEED AND FUEL YARD, C. 1933. Frank Leal's business was located on Pacific Avenue next to the present-day library. Feed, wood, and coal outlets were a fixture in most towns in the days when homes relied on the fuel for heating and cooking and the feed for poultry and horses. The photograph was made by an itinerant photographer from Hollywood Commercial Studios. Pictured from left to right are Frank Leal, Calvin Leal, and Eddie Pedro. (Courtesy T. Silva.)

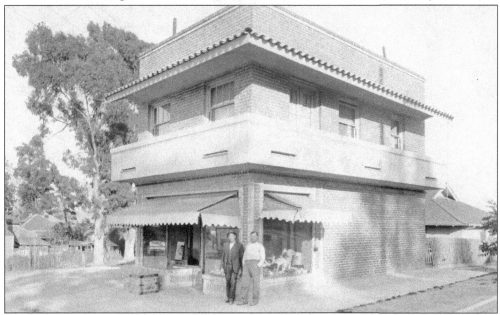

PACHECO STORE, PACIFIC AVENUE. Pacheco's general merchandise store and residence still sits at the junction of Rodeo and Pacific Avenues and First Street, although no longer used for commercial purposes. Jimmy "The Coop" Cooper (left) stands next to Anthony Pacheco. In the window at left is a Charlie Chaplin poster for the film *The Circus*, released in 1928. (Courtesy Judy and Frankie Adams.)

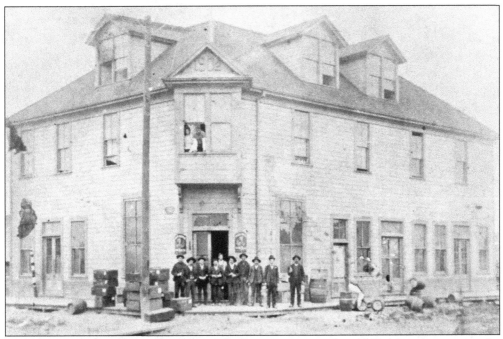

DEL MONTE HOTEL. The Del Monte Hotel was constructed in 1902 (above), opposite the Southern Pacific railway depot on San Pablo Avenue. Fifty-year-old hotelkeeper and carpenter Frank (Francisco) Del Monte, a native of Italy, and his wife, Ida, had 10 children. In 1892, Frank organized Rodeo's first fire department, a volunteer bucket brigade. Note the barber pole at left and the unpaved street. A fire that destroyed the oil refinery at Rodeo Beach on April 19, 1911, probably damaged this hotel. This rear view (below) is postmarked May 13, 1911. Its sender wrote: "This is part of my crowd that had to work on Sunday on necessary repairs." The hotel staff in white jackets peers out from the open doorway at left. (Above courtesy Marlene Nancett.)

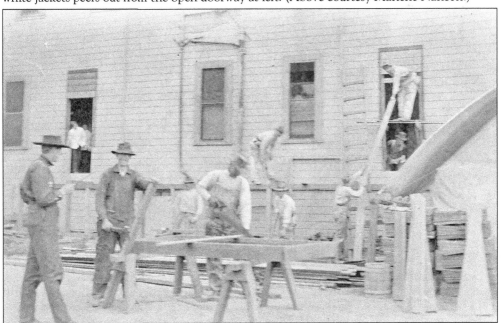

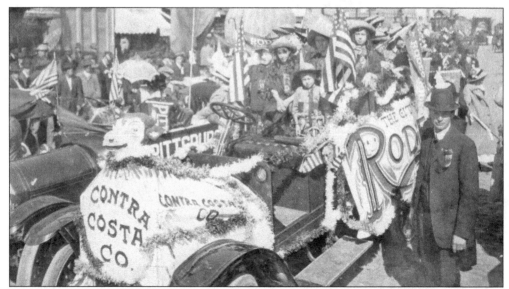

CITY OF RODEO FLOAT, APRIL 1915. "Watch 'em grow" was Rodeo's slogan at the Panama-Pacific International Exposition parade in San Francisco. The " 'em" refers to cows, one of which adorns the truck hood. Officially, the fair commemorated the opening of the Panama Canal, but it was really a celebration of San Francisco's revitalization following the 1906 earthquake and fire. Rancher Sebastian J. Claeys stands at the right. His son Linus is the small child in a hat near the vehicle's front. (Courtesy Valerro family.)

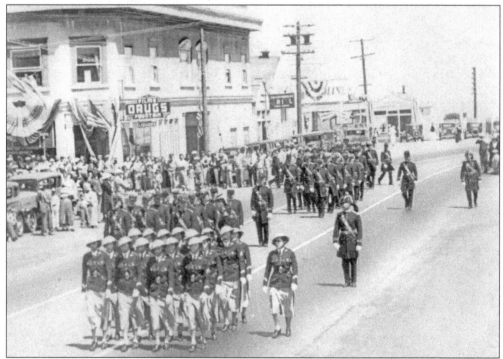

PARKER AVENUE PARADE. This is one of the many parades held in Rodeo to celebrate July Fourth and Veterans' Day. As the town grew, the parade route moved from Garretson Avenue and First Street to Parker Avenue. (Courtesy Tito Moreno.)

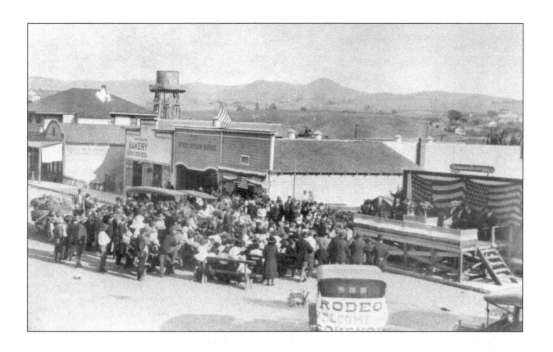

GOVERNOR STEPHENS, C. 1917. The crowd gathers to hear California governor William Stephens, whose years in office were remembered for a world war, Prohibition, and the suffrage movement. The commercial buildings on First Street include, from left to right, the Claeys market, A. Montero's bakery, the Rodeo Opera House, and the post office. In the photograph below, Governor Stephens, wearing his trademark bow tie, stands in front of 512 First Street, now occupied by Lakeman's. (Above courtesy Crockett Historical Society.)

A. G. Duarte's Tavern. A longtime institution on First Street is A. G. Duarte's tavern, later called Sunset Tavern and now known as Lakeman's. The bar (above, at left) at 512 First Street originally had two entrances. The one at right led to a barbershop. George and Lorraine Lakeman continue the business taken over by their family in the 1930s. (Courtesy Edward Sacca.)

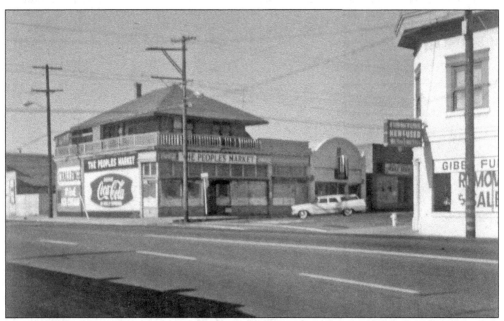

People's Market, 1962. The People's Market, advertised as "the biggest little store in Rodeo" at First Street and Parker Avenue, was built between 1895 and 1900. It survived two fires in the business district only to be declared unsafe and demolished in 1963. The store proprietors, Helen and Albert Wong, lived upstairs. Like many of the little grocery stores in Rodeo, the market offered free delivery. (Courtesy Dave Bunyard.)

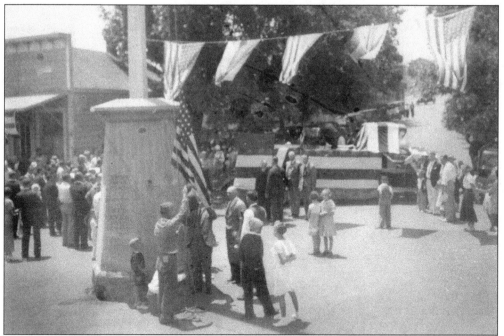

FIRST STREET FLAGPOLE. "Flagpole corner" on First Street at Rodeo Avenue was the focal point for many community gatherings. According to the *Contra Costa Gazette*, it was dedicated on Sunday, July 28, 1918, when "a beloved and patriotic woman," Marie Smith, raised the first flag. The pole was erected by the Rodeo Boosters Club and the Rodeo Volunteer Fire Department as a memorial to soldiers killed during the "Great War," which is now known as World War I. (Courtesy Tito Moreno.)

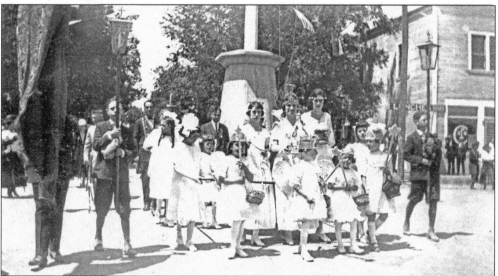

HOLY GHOST PROCESSION, JULY 1923. Twenty-year-old Tormey resident Josephine Suchowaski is queen of the Holy Ghost Festival (*Festa do Espírito Santo*). Her procession passes the flagpole on First Street headed toward Parker Avenue. The building at far right housed the Owens grocery downstairs and a barber; upstairs was a hall. Successor businesses included a bar called the Pilot House. This building survives today. (Courtesy Edward Sacca.)

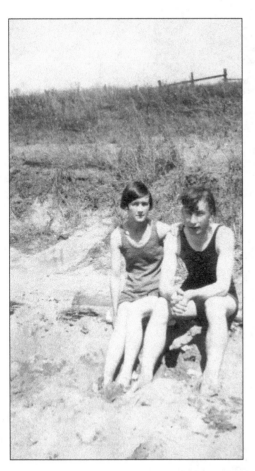

RODEO BEACH, 1925. Joe Thompson and a friend sun themselves at Rodeo Beach in the knitted wool bathing suits of the day. Recreational improvements were yet to be built. A pier on the eastern side of the marina constructed earlier had served the refinery and the ferry. (Courtesy Thompson family.)

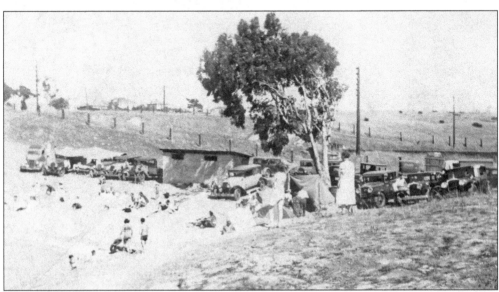

RODEO BEACH, 1936. At one time, beachgoers could pull their automobiles right up to the sand. The little building is a changing room. (Courtesy Edward Sacca.)

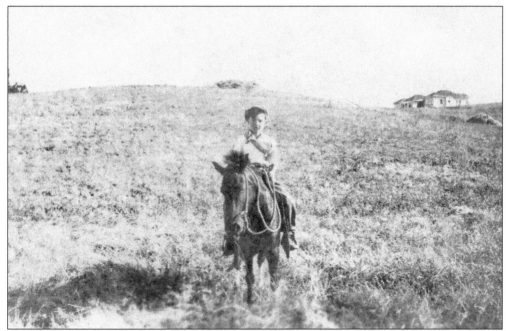

CASTRO YOUTH, 1927. This young horseman at Rodeo is a descendant of the Castro family. Don Francisco Castro, whose adobe home is located in San Pablo, was the first non-native settler to make his home in Contra Costa County and owned the largest rancho in the county. In the 1920s, the Castro ranch had a horseback unit that came to town for parades and rodeos. (Courtesy Thompson family.)

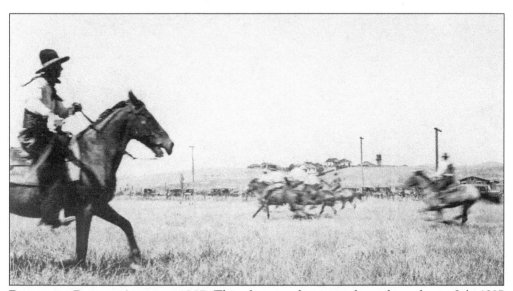

RODEO ON PARKER AVENUE, 1927. This photograph was made at the rodeo in July 1927 that also appears on page two. The houses and a prominent water tower are located on the Fourth Street hill east of Parker Avenue. The lineup of cars denotes Parker Avenue. (Courtesy Thompson family.)

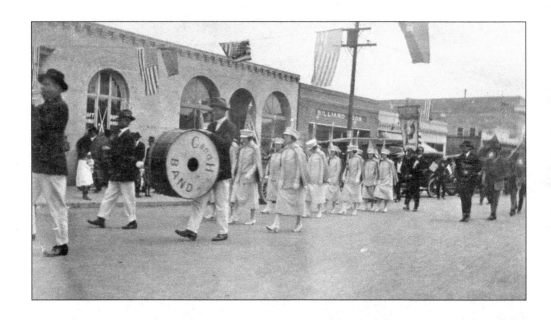

HOLY GHOST FESTIVAL, 1925. The annual Holy Ghost celebration in Rodeo was held under the auspices of the local I.D.E.S. (*Irmandade do Divino Espírito Santo*) Consul 96 on July 4 and 5, 1925. The view above shows the California and Hawaiian Sugar Refinery band on First Street approaching Rodeo Avenue. Flag carriers (below) are on Garretson Avenue. The two small houses on the immediate left are 373 and 377 Garretson Avenue and are among those built by John Slate. (Above courtesy Edward Sacca; below Valerro family.)

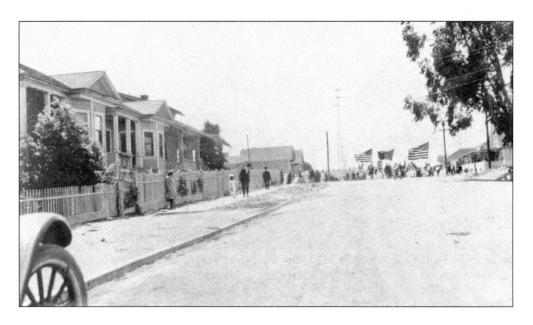

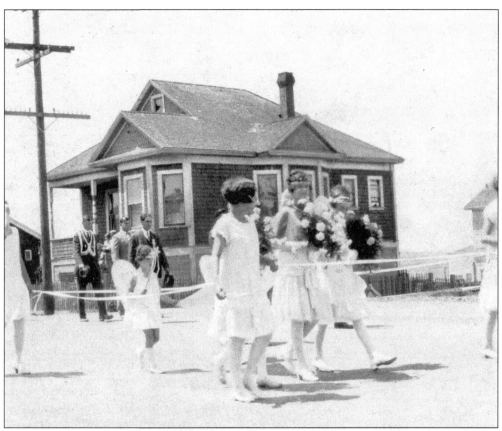

HOLY GHOST COURT, 1925. The Holy Ghost court passes 202 Garretson Avenue (above). The festival, originating in Portugal, is a Catholic celebration highlighted by the selection of a young woman to represent Queen Isabel. Olivia Pravio (at center) was crowned queen in 1925. Maids of honor were Adeline Rodriguez and Henrietta Cabral. The band members (below) pause in front of 158 Lake Avenue. The American Legion band of Crockett and Portuguese band of Oxnard also gave concerts. On Saturday, there was a parade with drill teams from Pinole, Oakland, Benicia, and San Pablo, plus an all-night dance. (Both courtesy Thompson family.)

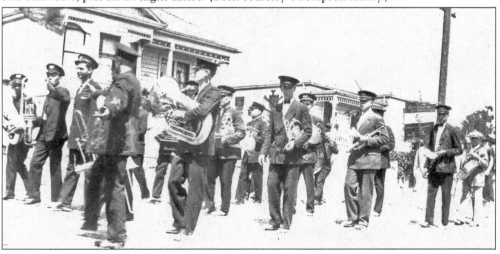

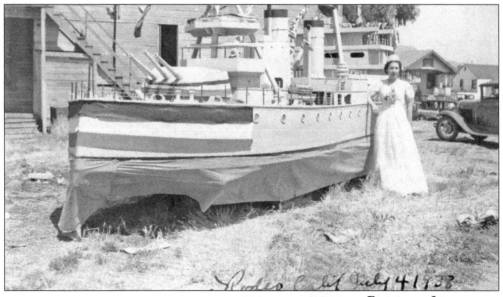

Rodeo Calif July 4 1938

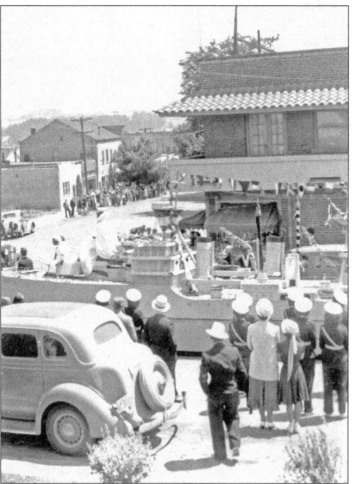

FOURTH OF JULY PARADE, 1938. Parade Queen Rose Rodrigues poses beside a float (above). Not seen is her court: Eleanor Floring of Richmond, Claire Arata of Crockett, and Marjorie Tipple of Rodeo. The local newspaper reported a "carnival, merrymaking" and a "monster" parade sponsored by the Rodeo Jesse Orchard Post 2798 Veterans of Foreign Wars. The Gold Star and World War mothers, the I.C.F. (Italian Catholic Federation) drill team of Crockett, and Odd Fellows cantons participated. In the image at left, the float passes the junction of Pacific Avenue and First Street headed east. Afternoon street dancing was followed by a grand ball at the Rodeo bank hall with the Lou Boss orchestra. (Both courtesy Edward Sacca.)

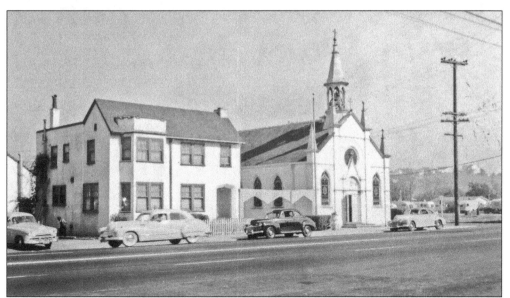

ST. PATRICK'S CHURCH. St. Patrick's Church (above) at Parker Avenue and Investment Street was dedicated in 1918 by his Excellency, the Most Reverend Archbishop Edward J. Hanna D.D. The construction cost for the Gothic-style building designed by Albert Porta of Oakland was $12,000. Eleven stained-glass windows costing $125 each were donated by local families. Twenty-eight pews seated 196. St. Patrick's became a parish in 1923, and the parish house was built the next year at a cost of $10,000 plus another $3,500 for furnishings. The interior view (below) with Paul Sacca at the altar is dated May 1957. After the church relocated to Seventh Street, this building was burned down in 1967 as a firefighter training exercise, but the bell was moved to St. Patrick School. (Below courtesy Edward Sacca.)

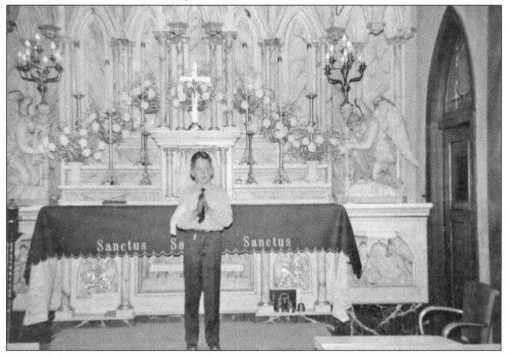

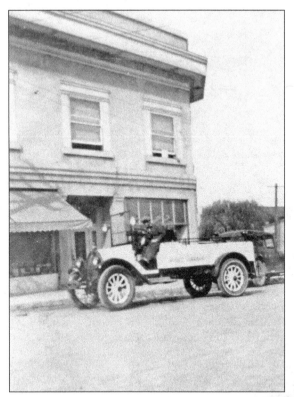

RODEO AUTO REPAIR TRUCK. The truck is parked outside Hearne's drugstore on First Street near Parker Avenue. This is the only block in Rodeo that retains diagonal parking.

HEARNE'S DRUGSTORE, 530 FIRST STREET. "Doc" William Hearne (left) sits outside his drugstore next door to the bank. Vernon Valerro sits on the right. Behind him is Fred Nunemann. The original photograph was captioned, "Doc personally recommends Fitch's hair tonic. Note the luxurious growth of chestnut hair Doc sports in this snap." This store was later operated as a Rexall by Carmen and Vincent Ruggeri. The store is now a collectibles shop, but the tile floor of the drugstore is intact. (Courtesy Valerro family.)

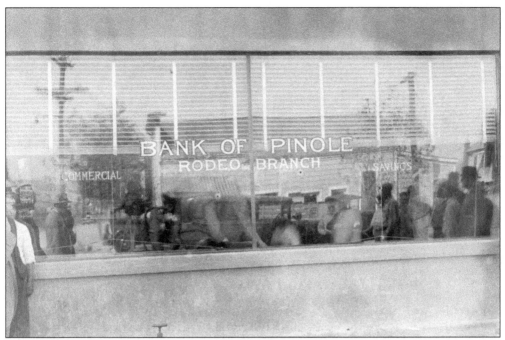

BANK ROBBERY, 1929. A crowd of onlookers is reflected in the Bank of Pinole window after gunshots pierced the window during a robbery in September 1929 (above). Three bandits stole $27,000 and killed Sheriff Arthur "Jerry" MacDonald. Some two years later, another robbery was attempted. Arthur "A. D." Dern, in charge of the office, was able to trip the alarm and pursue the burglars all the way to Tormey, where a struggle over the gun occurred. Another man followed the chase and shot the bandit in the leg. The photograph below shows the building at First Street and Parker Avenue that housed the Rodeo Townsite real estate company and a dance and lodge hall, later to become a bowling alley, on the second floor. Downstairs was a drug store, bank, theater, and café. (Both courtesy Werth family.)

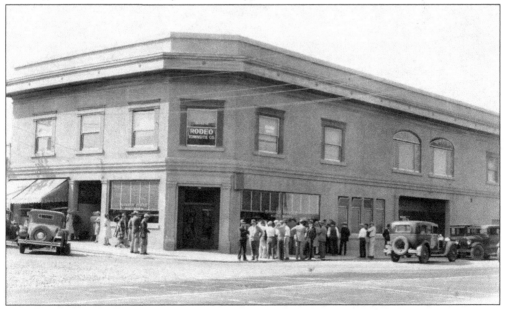

RODEO LIBRARY, 1978. The Rodeo Library, which opened in 1914, was located in various buildings during its first years of operation. In 1926, the library moved into the former kindergarten classroom building shown here. The school building was placed on a site given by the Rodeo Townsite and Improvement Company for $1 consideration. The double-hung windows seen here were added in 1947.

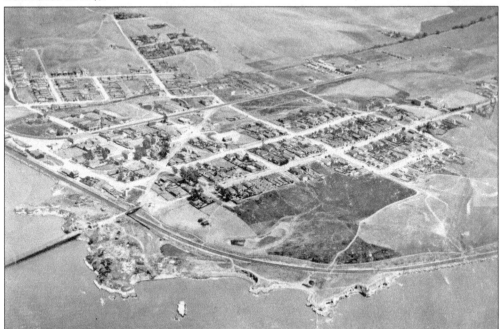

AERIAL VIEW, 1927. The aerial view of Rodeo shows a compact town. Yet to come are the Bayo Vista housing project; the Rodeo Vista, Rodeo Highlands, and Viewpointe housing tracts; the Foxboro development on the Hercules side of Willow Avenue; and Interstate 80. The marina had not yet been developed. In the 1930s, the pier at Joseph's Resort would be built out to the little island in the cove. (Courtesy David Claeys.)

Two

SCHOOL DAYS

PANORAMA, 1893. This 1893 view shows the Rodeo School (the white building at left with three windows) on Sixth Street between Garretson and Lake Avenues. The waterfront is to the right; Tony Lima's house sits at the base of the hill. In 1893, there were 28 children attending classes, ages 5 to 17. The previous school, located in Rodeo Valley, was established in 1864. Ida Siedel was the first teacher in town. Her pupils included children from the families of Del Monte, Joseph, Cardoza, Silva, Higuera, Cooper, and others. It is said that when the wooden school was torn down, Jerry Mahoney bought the lumber to use for two houses at Lake Avenue and Sixth Street. (Courtesy Harry Nancett.)

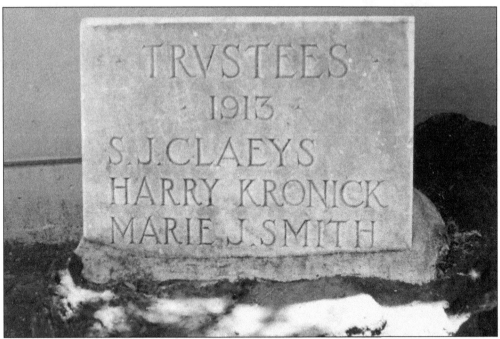

RODEO SCHOOL CORNERSTONE. The 1913 cornerstone of the Rodeo School was photographed 80 years later, when it sat outside the Garretson Heights Elementary School's administrative offices. The first trustees were Marie J. Smith, Harry Kronick, and S. J. Claeys, who served in that capacity for many years. Marie Smith was also active in the local library. Kronick and Claeys were town merchants.

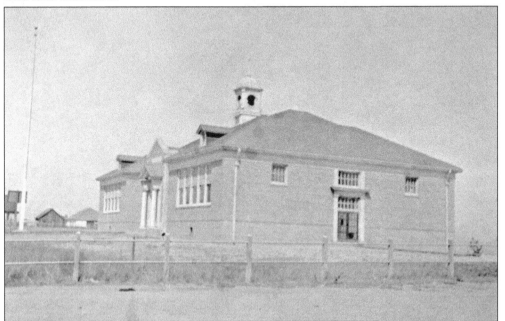

SOUTH SIDE OF RODEO SCHOOL, 1913. The view looking at the south side of the Rodeo School was taken around the time of construction, before any landscaping had occurred. (Courtesy Jim Brownlee.)

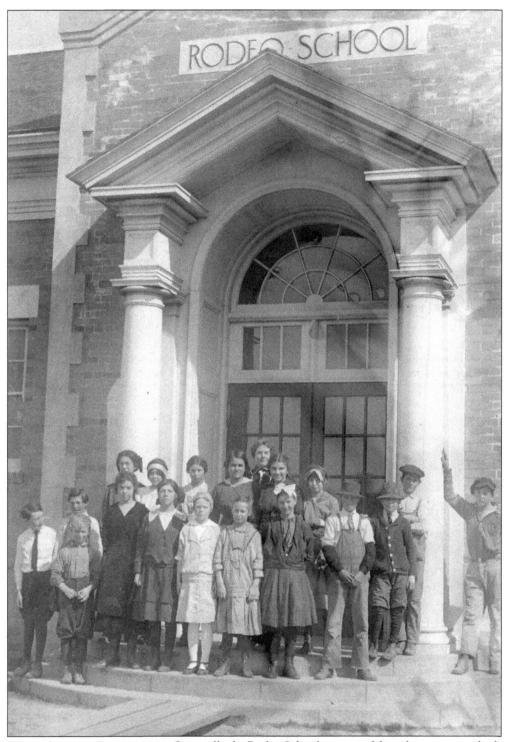

RODEO SCHOOL, EARLY 1920S. Originally the Rodeo School contained four classrooms in which eight grades were taught. An upper-grade class poses on the steps of the Rodeo School, while Principal Anastasia Dean stands at the rear. (Courtesy Valerro family.)

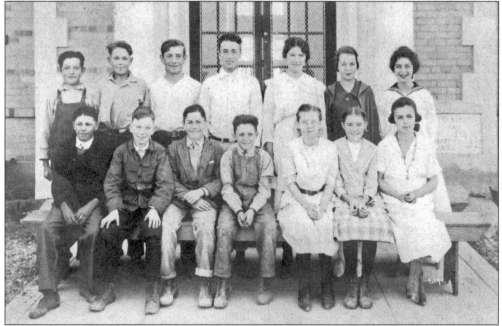

RODEO SCHOOL DIPLOMA, 1921. This beautifully lettered diploma was issued to Joseph Thompson upon his graduation from the Rodeo School. (Courtesy Thompson family.)

RODEO SCHOOL, 1919. The names of the seventh- and eighth-grade classes were recorded on the reverse of this photograph. The children are from left to right, beginning with the back row: Tony Pangrasio, George Maloch, Kenneth Peterman, Charles Leno, Lasca Stintson, Nellie Thompson, Doris Cory, Peter Nancett, Joseph Thompson, Manuel Sabrel, Frank Kansangrad, Josephine Claeys, Lillian Bissell, and unidentified. (Courtesy Valerro family.)

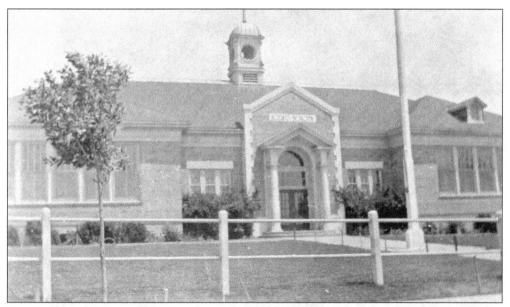

RODEO SCHOOL, 1913. This view shows the Rodeo School in 1913, just after it opened. The cupola above the entrance, which had a bell that called students to classes, was later removed to be replaced by an electric bell system. Over the next 17 years, the school was enlarged, but by 1951, the building had been declared unsafe. A new structure was authorized that was completed two years later. (Courtesy Jim Brownlee.)

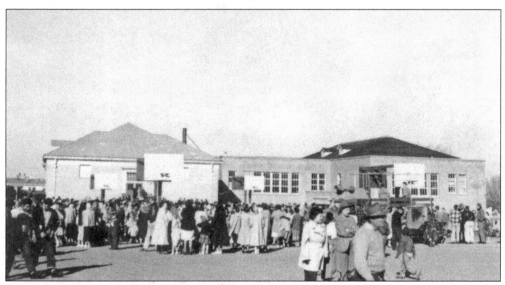

REAR OF GARRETSON HEIGHTS SCHOOL, 1951. The Rodeo School was renamed Garretson Heights but was also commonly referred to as Garretson School, a name that harkens back to one of the founders of the Union Stock Yard Company. This rear view shows the classrooms added in 1924 and 1930, according to construction dates recorded on fire insurance maps.

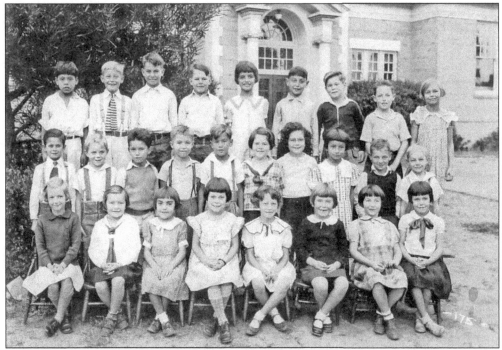

SECOND-GRADE CLASS, 1935. The 1935 second-grade class assembles at the front of Rodeo School. Only a few are identified: back row, seventh from left, is Art Cooper; middle row at left is Lloyd Cardoza, seventh from left is Marie Weil (daughter of the town physician), and ninth from left is Joey Longo; second from left in the first row is Alice Brady, and fifth from left is Elaine Lavering. (Courtesy Elaine [née Lavering] Lindner.)

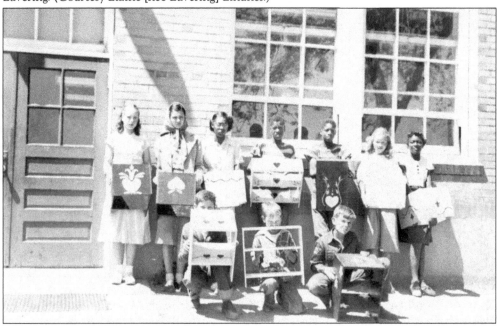

GARRETSON CLASS PROJECTS, C. 1951. Standing at the rear of the school, a Garretson School class proudly holds their shop projects.

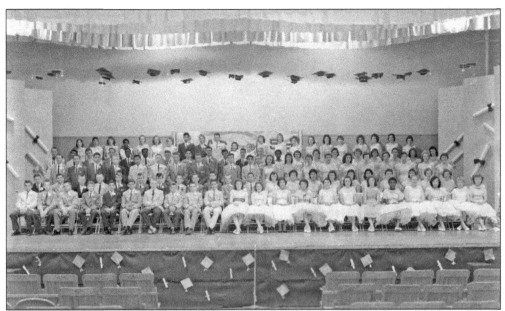

EIGHTH-GRADE GRADUATES, 1958. The Hillcrest and Garretson eighth-grade graduating classes sit on the stage at Garretson's auditorium. For most of the girls, this was their first time in high heels and a prom dress, and it was perhaps the first time in a suit or sports coat for the boys. (Courtesy Marcia M. Raborn.)

GARRETSON SCHOOL KINDERGARTEN BUILDING. A $75,000 building to house a kindergarten and music room was under construction in 1963, replacing a temporary building that had been used for classrooms for many years. These buildings and all others on the campus were razed to clear the parcel for the construction of the Rodeo Hills Elementary School.

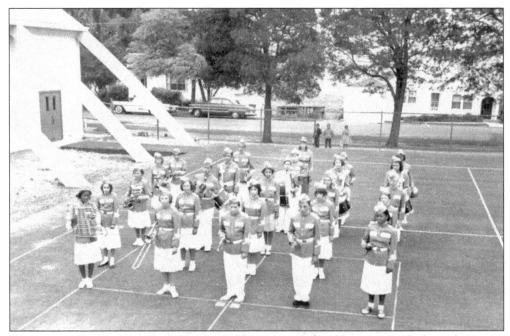

GARRETSON HEIGHTS SCHOOL BAND, 1962. The Garretson band lines up outside the multipurpose building where sports events, plays, concerts, and school dances were held, as well as many community events, including whist party fund-raisers sponsored by various groups. (Courtesy Thompson family.)

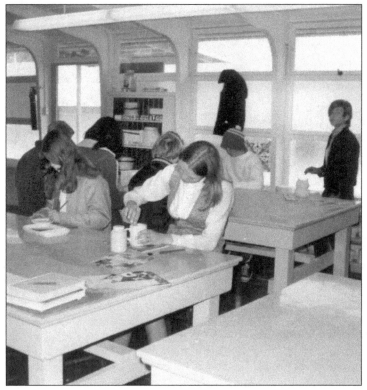

GARRETSON HEIGHTS SCHOOL TEMPORARY BUILDING. Students work on art projects in the "temporary" building at Garretson that served the school for several decades. At center is Michelle Roque. Marty Nancett faces the camera.

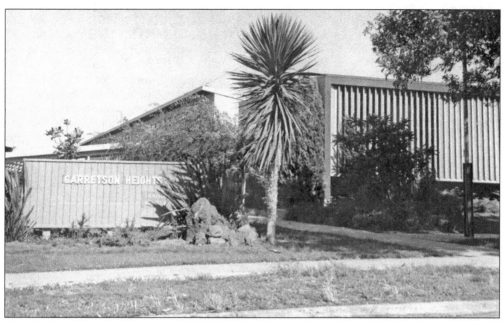

GARRETSON HEIGHTS SCHOOL OFFICES. The administrative offices and library at Garretson Heights Elementary School are shown above. The school, first occupied in 1953 and closed in 1982, was temporarily leased as an alternative school and then reopened as a public school.

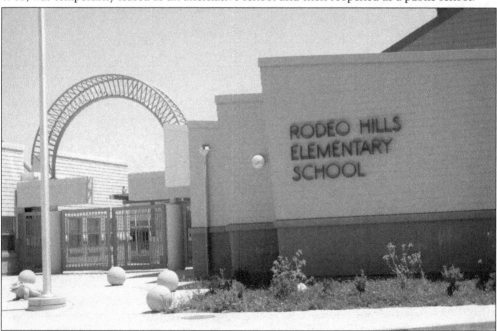

RODEO HILLS ELEMENTARY SCHOOL. This new school opened in 2004 on the old Garretson site following a decision to close the Hillcrest School on California Street, which had a population of some 900 students. Rodeo Hills was designed by Oakland's VBN Architects. The State of California contributed $6.19 million to build the new school, with about half the amount as an advance against the proceeds of selling the Hillcrest school property, subsequently purchased and cleared by ConocoPhillips.

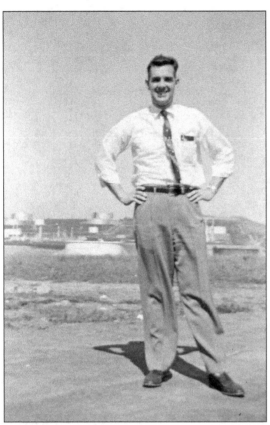

HILLCREST PLAYGROUND VIEW, 1957. In 1957, teacher Mr. Green poses on the eastern edge of the playground at Hillcrest School. The refinery in the background was a factor in eventually closing the school, as residents were concerned about emissions and how to quickly evacuate children in the wake of a catastrophic event. The refinery is now owned by ConocoPhillips. (Courtesy Marcia M. Raborn.)

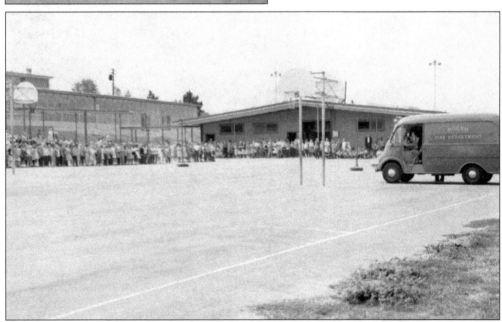

HILLCREST SCHOOL UPPER-GRADE CLASSROOMS. The Rodeo Fire Department presents a program on the playground outside the classrooms on the north side of Hillcrest. In subsequent years, manufactured buildings were also added as classrooms.

HILLCREST ELEMENTARY SCHOOL OFFICE. This school was built in 1948 with 12 rooms. In 1950, four rooms were added on the east side, and in 1952, the kindergarten and multipurpose room were added. With the building of Hillcrest, the Bayo Vista School, which had been functioning as an annex, was closed.

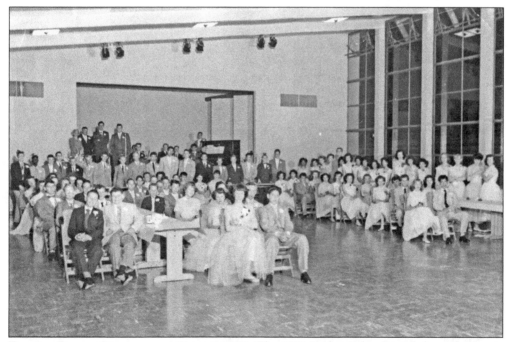

EIGHTH-GRADE GRADUATION PARTY, 1953. The 1953 Rodeo School's eighth-grade class is dressed for a graduation dance at the Hillcrest multipurpose room. Corsages and boutonnieres were provided by the parent-teacher association. (Courtesy Silva family.)

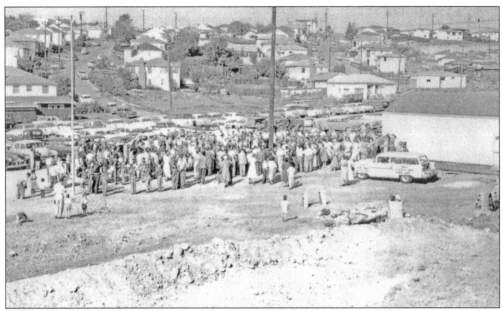

St. Patrick School Raffle, 1956. On October 28, 1956, St. Patrick School raffled a new Chevrolet station wagon, with the winner announced at the fall festival held at Bayo Vista Auditorium. Construction of the auditorium-church building would begin in December 1957 on the graded lot in the foreground. The Rodeo Vista subdivision lies beyond the school grounds. A single developer built 100 homes in that tract, but many were individually constructed. (Courtesy Judy and Frankie Adams.)

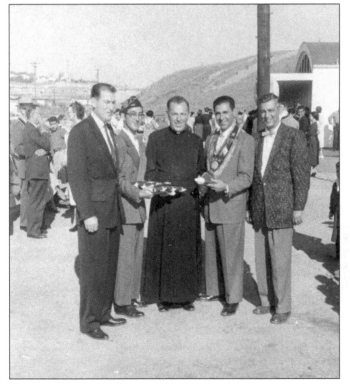

Flag Presentation, 1956. On October 14, 1956, Raymond H. Shone of the San Rafael chapter of the Native Sons of the Golden West presented the Stars and Stripes to Father George E. Moss at St. Patrick School. Representatives of the Crockett, Martinez, Richmond, Antioch, Walnut Creek, and Byron chapters attended. The public was invited to enjoy refreshments served by the Mothers' Club. (Courtesy Frank and Sheri Silva.)

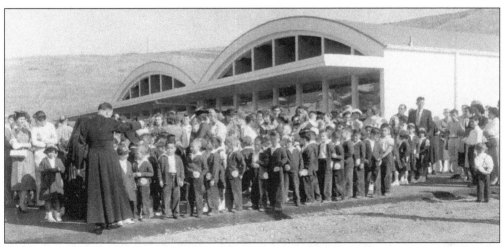

St. Patrick School Assembly, 1956. The school had been only open one month when Fr. George E. Moss assembled the 150 pupils for the flag ceremony. Staffed by the Sisters of the Immaculate Heart of Mary, the new school offered grades one to three that first year. Four additional classrooms were scheduled to begin construction that fall to be completed by July 1958, allowing the school to grow to include fifth through eighth grades. Albert Hunter Jr. was architect for the project. (Courtesy Frank and Sheri Silva.)

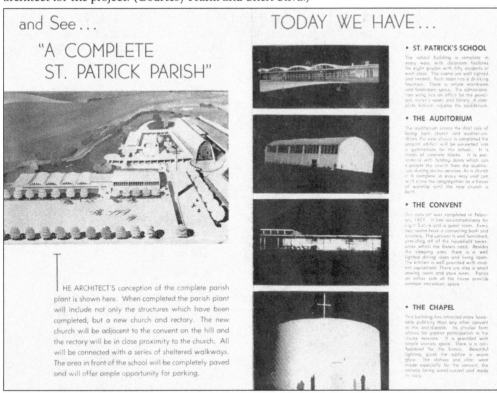

and See...

"A COMPLETE ST. PATRICK PARISH"

THE ARCHITECT'S conception of the complete parish plant is shown here. When completed the parish plant will include not only the structures which have been completed, but a new church and rectory. The new church will be adjacent to the convent on the hill and the rectory will be in close proximity to the church. All will be connected with a series of sheltered walkways. The area in front of the school will be completely paved and will offer ample opportunity for parking.

TODAY WE HAVE...

• ST. PATRICK'S SCHOOL

The school building is complete in every way, with classroom facilities for eight grades with fifty students in each class. The rooms are well lighted and heated. Each room has a drinking fountain. There is ample washroom and bookroom space. The administration wing has an office for the principal, nurse's room, and library. A complete kitchen adjoins the auditorium.

• THE AUDITORIUM

The auditorium serves the dual role of being both church and auditorium. When the new church is completed the present edifice will be converted into a gymnasium for the school. It is made of concrete blocks. It is partitioned with folding doors which can separate the church from the auditorium during divine services. As a church it is complete in every way and can well serve the congregation as a house of worship until the new church is built.

• THE CONVENT

This convent was completed in February 1957. It has accommodations for eight Sisters and a guest room. Every two rooms have a connecting bath and lavatory. The convent is well furnished, providing all of the household necessities which the Sisters need. Besides the sleeping area, there is a well lighted dining room and living room. The kitchen is well provided with modern equipment. There are also a small sewing room and store room. Patios on either side of the house provide outdoor recreation space.

• THE CHAPEL

This building has attracted more favorable publicity than any other convent in the archdiocese. Its circular form allows for greater participation in the divine services. It is provided with simple laundry space. There is a confessional for the Sisters. Beautiful lighting gives the edifice a warm glow. The statues and altar were made exclusively for the convent, the statues being wood-carved and made in Italy.

St. Patrick School Campaign. This brochure illustrates the vision for the new St. Patrick facility. John Pereira headed the fund-raising campaign with Edward Lewis as cochairman. In 1982, fire claimed the entire school wing, but the classrooms have since been rebuilt. The original church (now used as an auditorium) and chapel survived the fire. (Courtesy St. Patrick School.)

49

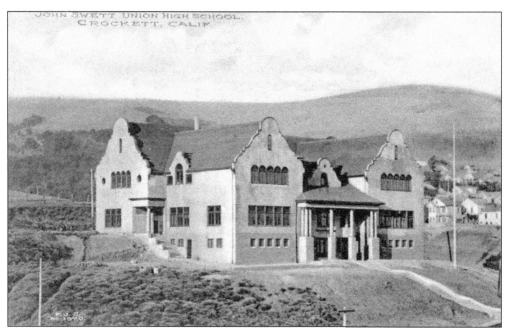

JOHN SWETT HIGH SCHOOL, 1909. High school classes were initially held in the grammar school at Crockett, and in April 1909, this building opened near the site of the current John Swett High School. The school was named for the father of public instruction in California. The first year's enrollment was 40 students, and by 1927, it had climbed to more than 200, necessitating larger quarters. (Courtesy Raymond L. Raineri.)

JOHN SWETT HIGH SCHOOL, 1928. John Swett High School, dedicated in 1927, serves the Rodeo population as well as Crockett and surrounding areas. The bridge (background) and high school opened the same year. In the early years, the emphasis was on vocational instruction and shop work. Since this photograph was made, the attic story has been removed as part of earthquake retrofitting. (Courtesy Raymond L. Raineri.)

Three

THE FIRE DEPARTMENT

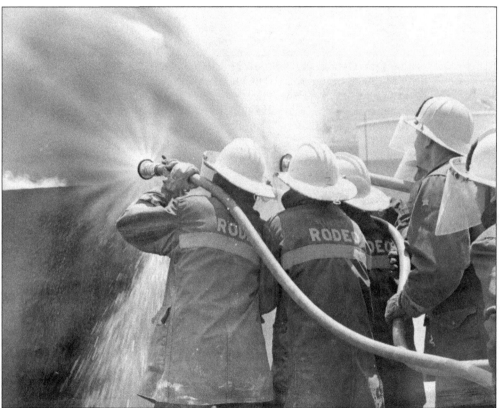

RODEO FIRE DEPARTMENT DRILL, C. 1969. These Rodeo firefighters are participating in an oil-fire training drill at Union Oil Company, which was an annual occurrence until 1970. Rodeo experienced major fires in 1915 and 1927 in the business district and a big residential blaze in November 1911. In 1892, a volunteer fire department was organized, and in 1927, a brick firehouse for Rodeo was constructed. The district joined with Hercules in the early 1980s. Today's Rodeo-Hercules Fire Protection District covers a 26-square-mile area that includes a major oil refinery, grasslands, two major rail lines, State Route 4, Interstate 80, an industrial park, and the residential and retail districts of Rodeo and Hercules. Fire Station No. 75, the present building, was dedicated in February 1996. Delmar M. Kramer, a local appliance dealer who assisted the department for several decades, served as chair of the building committee. The department responds to rescue, public assistance, and mutual-aid calls, as well as fires. (Courtesy Rodeo-Hercules Fire Protection District.)

RODEO VOLUNTEER FIRE DEPARTMENT SHED. The department hose cart was stored on First Street in the heart of the business district. The photograph is dated around 1926 based on the advertisement on the fence for the State Theatre in Martinez, which opened that year. The building at the left had many uses: a saloon, notions store, library, and dwelling. Only the word "Occidental" is visible on its sign. (Courtesy Jim Brownlee.)

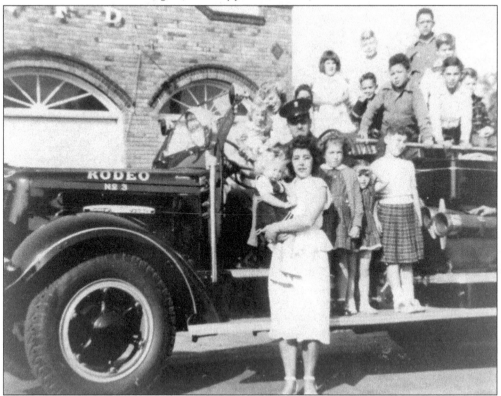

FIRE TRUCK NO. 3. Fireman Hugo Braga gives a group of lucky children a chance to climb aboard a 1945 White fire truck. The truck could pump at the rate of 500 gallons per minute. (Courtesy Rodeo-Hercules Fire Protection District.)

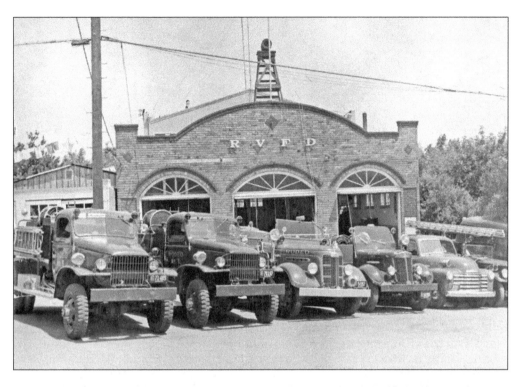

FIRE STATION, THIRD STREET. The Rodeo Volunteer Fire Department station was dedicated in April 1927. The purchase of land was done under the leadership of fire chief E. Gomez with individual community members guaranteeing notes for the construction cost. The two fire engines on display at left are among the army-surplus Power Wagons acquired by civilian departments after World War II. The station was modified several times during the nearly seven decades it served the department. Below, assistant fire chief Don Selvester stands in the open bay. At left is the bell that once rang from a cupola on the roof of the nearby Rodeo School. (Top courtesy of Rodeo-Hersules Fire Protection District.)

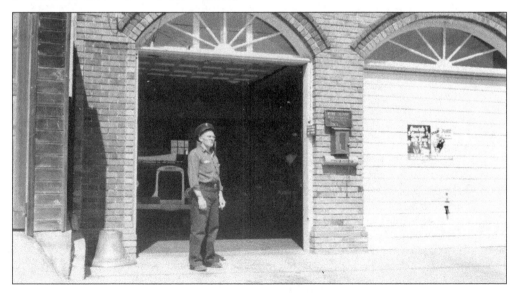

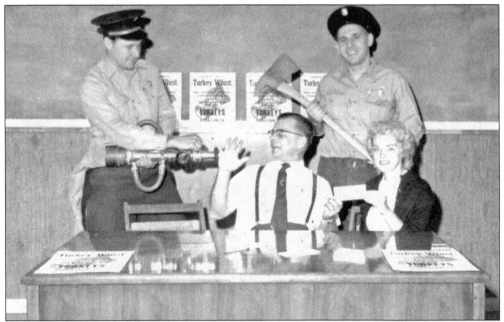

FIRE DEPARTMENT FUND-RAISER, 1959. A "Turkey Whist" party fund-raiser for the fire district is being planned by, from left to right, W. R. Bepler, Del Kramer, F. Penfield, and Sandy Trigliatta. (Courtesy Rodeo-Hercules Fire Protection District; photograph by George Serpa.)

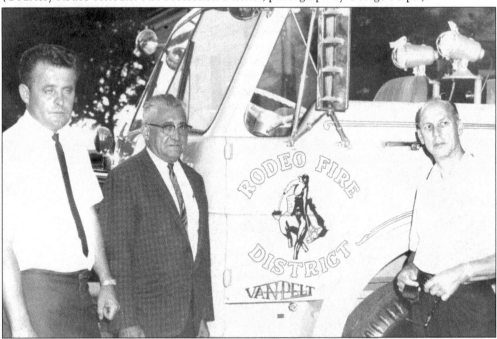

FIRE COMMISSIONERS, 1966. The fire commissioners are, from left to right, Don Davies, Harry D. Canet, and George Schandelmier, who also served on the school board. Davies arrived in Rodeo in 1955, following World War II service that earned him the Distinguished Service Cross, the Bronze Star, and two Purple Hearts. He served as a fire commissioner for 30 years. Note the rodeo-rider logo on the truck. (Courtesy Rodeo-Hercules Fire Protection District.)

FIRE COMMUNICATIONS CENTER, 1959. P. Kellum works the radios at the Rodeo fire station. Personnel were summoned to duty either by sounding the siren or by telephone call—the "silent" alarm. (Courtesy Rodeo-Hercules Fire Protection District.)

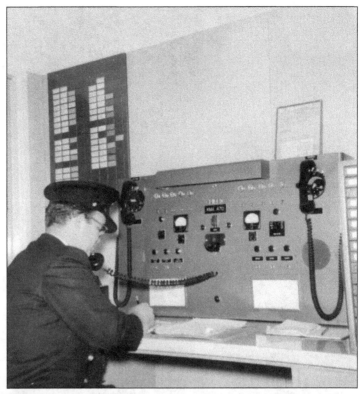

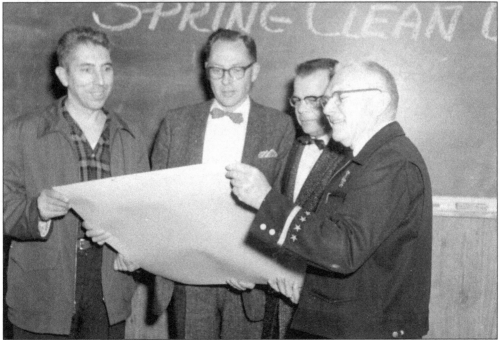

SPRING CLEAN-UP, 1960. The Spring Clean-Up committee included, from left to right, Edward Sacca (Tri-City Auto Supply), Will Cluff (Rodeo School District), Del Kramer (Del Kramer's Appliances), and Don Selvester. (Courtesy Rodeo-Hercules Fire Protection District.)

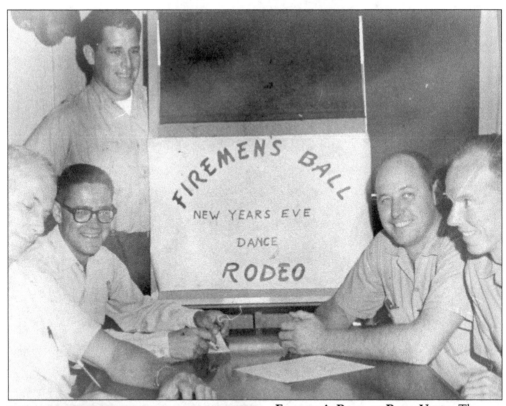

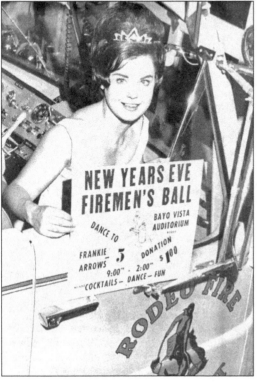

FIREMAN'S BALL AT BAYO VISTA. The fireman's ball was an annual fund-raiser held at the Bayo Vista auditorium. The planning committee shown above includes Bob Dominquez (standing) and (seated from left to right) Pete Norgaard, Dave Bunyard, Ron Bepler, and Tom Birdwell. Judy Deleau (at left) holds a poster advertising the 1966 New Year's Eve Fireman's Ball, which had an admission price of only $1. (Courtesy Rodeo-Hercules Fire Protection District.)

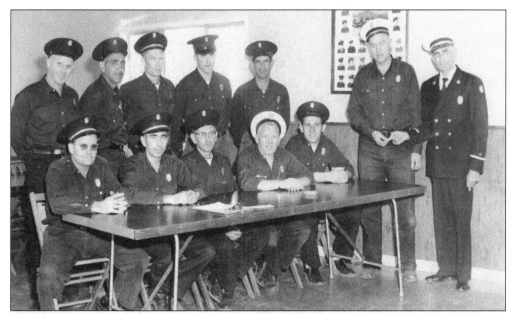

FIRE DEPARTMENT TRAINING, 1956. Lloyd Cooper, standing in front of the department portraits, was chief from 1937 to 1965 and was known as a dedicated trainer. In 1956, the crew gathered for Red Cross training. Standing from left to right are A. Hibbs, Cecil Cunha, Art Cooper, Jack Scandlyn, Henry Cunha, Chief Lloyd Cooper, and an unidentified visitor. Seated from left to right are Don Ely, Francis Zeigler, Fred Felton, Don Selvester, and unidentified. (Courtesy Rodeo-Hercules Fire Protection District; photograph by George Serpa.)

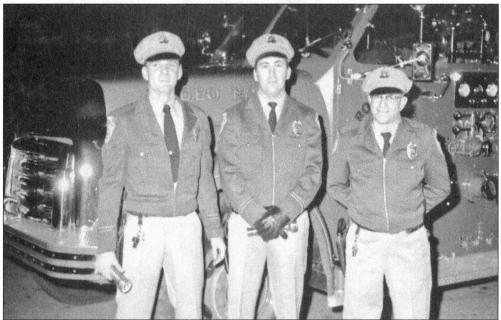

CONTRA COSTA SHERIFFS. Officers from the sheriff's department routinely handled traffic at accident scenes and fires. Pictured here from left to right are Ron Grey, David Gonyer, and Leo Surette. These men were part of a force that was called up as needed, similar to the volunteer fire department. (Courtesy Rodeo-Hercules Fire Protection District.)

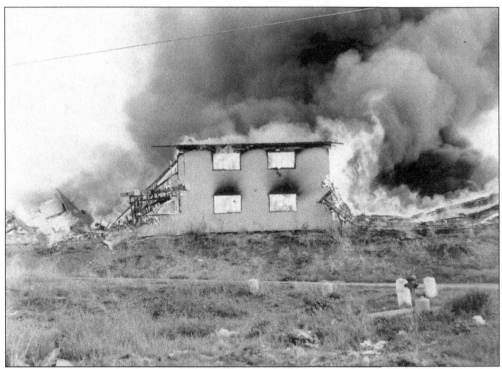

FIRE DEPARTMENT TRAINING DRILLS. In 1963 and 1964, apartments at Bayo Vista were burned as practice for fighting apartment fires. Four or five districts participated in the exercise. Many of the 1,000 apartment units not burned were torn down.

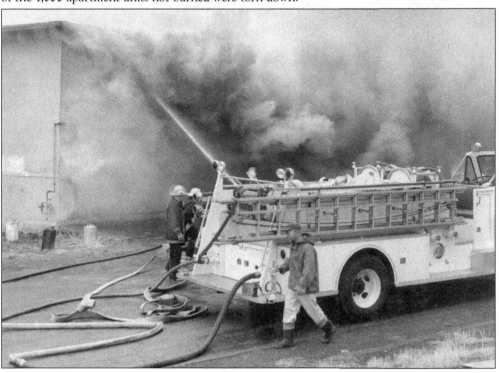

Four

TRANSPORTATION

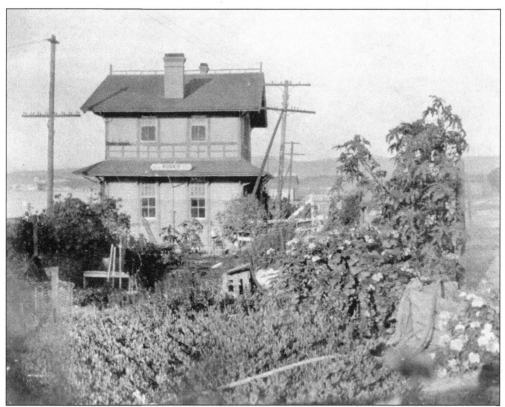

SOUTHERN PACIFIC DEPOT, 1915. The Rodeo passenger and freight depot on San Pablo Avenue was located just east of the railroad bridge. It was completed in June 1892 at a cost of $5,000 as a one-story structure. The second-floor stationmaster's house was added about 10 years later. In the early 20th century, railroad telegrapher Luna B. Clarke, who also managed the post office at the depot, lived upstairs. She planted the garden seen here.

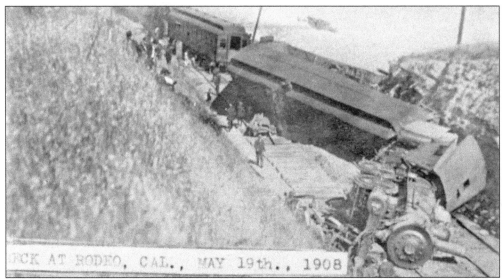

RCK AT RODEO, CAL., MAY 19th., 1908

TRAIN WRECK AT RODEO, 1908. Southern Pacific's *Oregon Express* derailed near present-day Joseph's Resort on May 20. (The photograph date is incorrect.) The engine was No. 1446, known as the "hoodoo engine," and had been recently involved in another accident with the *Owl* train at Newman. According to the local newspaper, four railroad employees were killed, as well as an unknown "tramp." This tragedy did have one positive outcome: it kindled a romance and marriage between Rodeo teacher Cecilia Henry, who was one of the injured passengers in the day car, and Leander Gifford, a Southern Pacific baggage man.

RAILROAD DEPOT, 1911. This photograph shows the north side of the Rodeo depot and two buildings on San Pablo Avenue: the White House Café at left and the LaGrand Hotel to the right. In 1878, the Northern Railway operated this right-of-way between Oakland and Avon, forming the western water-level link of the transcontinental railroad route. The right-of-way passed to Southern Pacific and is now owned by Union Pacific. (Courtesy California History Section, California State Library.)

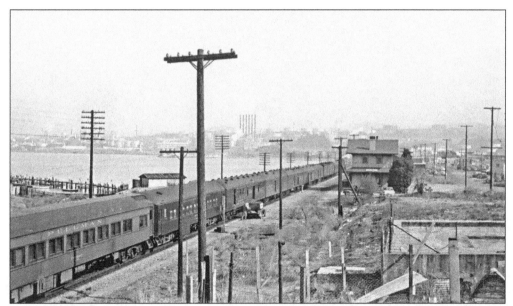

SOUTHERN PACIFIC TRAIN NO. 56, 1948. A Southern Pacific freight train stops at Rodeo to transfer packages from the Railway Express Company car (mid-photograph). Mail was dropped at the depot, but Rodeo was a flag stop to entrain or detrain passengers. (Courtesy John Harder.)

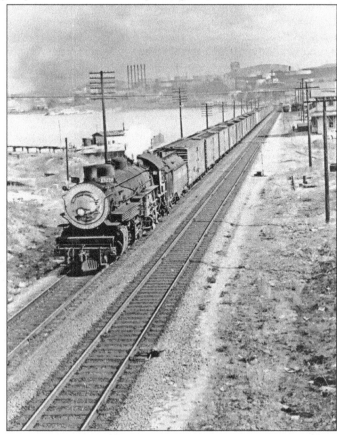

SOUTHERN PACIFIC ENGINE X3228, 1952. It is October 12, and a Southern Pacific steam engine followed by its coal tender pulls freight by the Rodeo depot as it heads in-bound to Oakland. In the early 1950s, steam-powered locomotives were in their declining years. This view shows the double through-line tracks on which trains move east and west. (Courtesy John Harder.)

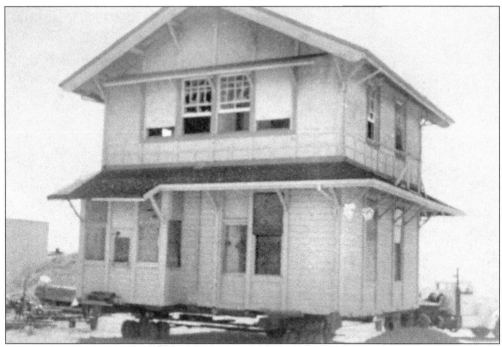

RODEO DEPOT, 1974. The railroad depot was removed, hauled over the railroad bridge to the waterfront, and then transported by barge to Napa Junction at American Canyon Road for intended restaurant and bar use. The restaurant never materialized, and the dilapidated building was eventually burned by the fire crew there as a training exercise. (Courtesy Crockett Historical Society.)

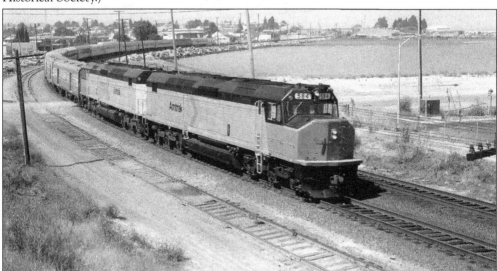

AMTRAK ZEPHYR, JULY 1975. The Amtrak Zephyr was part of an attempt to revive passenger rail service. Congress created Amtrak, a private company, which in May 1971 began managing a nationwide rail system dedicated to passenger service. The passenger trains on the Capitol Corridor route are run on Union Pacific tracks controlled by dispatchers in Omaha, Nebraska, who are in the business of moving freight, and freight gets priority over passenger service. (Courtesy John Harder.)

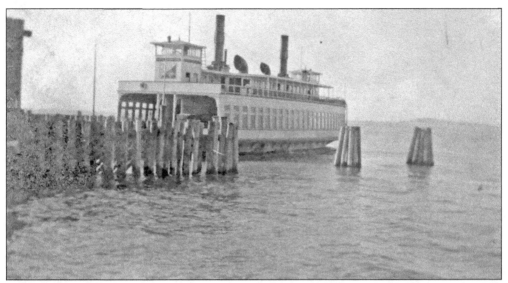

AVEN J. HANFORD FERRY. The Rodeo-Vallejo Ferry run began on July 4, 1918, following the arrival of the ferry boat *Issaquah* after what was described in the *Contra Costa Gazette* as "sundry misadventures" on the ocean-going voyage from Seattle. In Vallejo, the ferry docked at the foot of Lemon Street. Shown here is the company's *Aven H. Hanford* (named in honor of a company founder) arriving at Rodeo. It was a twin-stacked steamer that carried 65 automobiles and passengers and whose machinery and boilers came from the destroyer *Farragut*. (Courtesy Edward Sacca.)

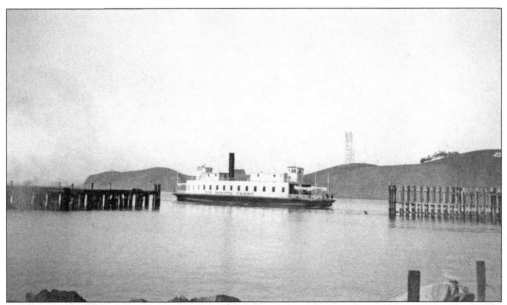

SIX-MINUTE FERRY. This is the *San Jose* (photographed at Crockett), which was acquired in 1922 from the rival Six-Minute Ferry line and put into service running opposite the *Issaquah* on the Rodeo-Vallejo Ferry's twice-hourly crossing, which actually took 11 minutes. Originally built in 1903, it was extensively altered following a 1919 fire. Following the purchase of the *San Jose*, the *Hanford* was moved to the Golden Gate Ferry line. (Courtesy Raymond L. Raineri.)

CARS CROSSING RAILROAD BRIDGE. In this early-1920s view, a line of touring cars, the Sunday driving car, crosses the Southern Pacific bridge headed for the Rodeo Beach and ferry landing. Note the spoked wood wheels. (Courtesy Jim Brownlee.)

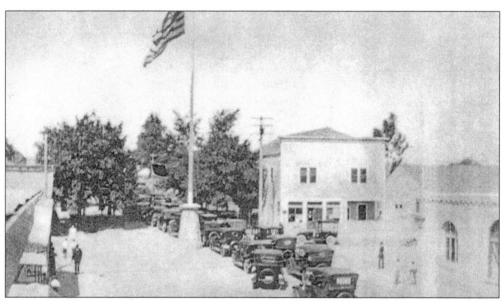

AUTOS LINED UP FOR FERRY. The increasing number of automobiles on the road would soon lead to the construction of a bridge spanning the Carquinez Straits. This traffic on First Street at Rodeo Avenue is bound for the Rodeo Beach ferry crossing. (Courtesy Dave Bunyard.)

COUNTY ROAD, 1925. A bewildering array of signs is visible at the junction behind the stripped Ford Model T roadster. Straight ahead is an auto ferry. The left arrow points to the Rodeo-Vallejo Ferry, the "short way" to Sacramento. A right arrow directs motorists to Franklin Canyon and the Martinez ferry. Note the hand crank for starting the motor. (Courtesy Thompson family.)

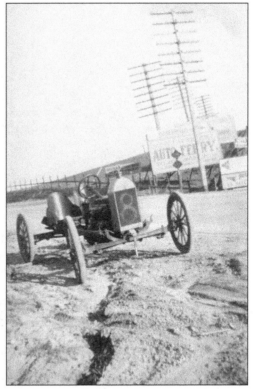

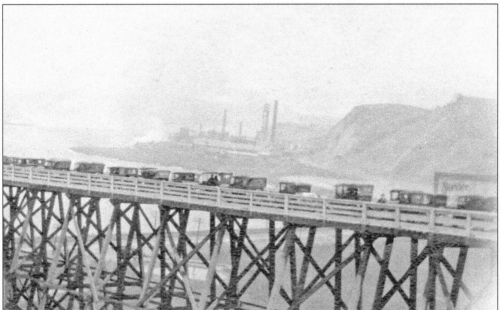

FERRY TRAFFIC, 1925. This is the Rodeo-Vallejo Ferry after it moved operations from Rodeo to a pier at Selby. The smelter can be seen in the background. The photograph was taken on July 4, 1925, a record-setting day, with 4,000 cars crossing on the nearby Carquinez-Benicia ferry, one of several operating in the area. This line carried 1,437,527 passengers for the fiscal year ending June 30, 1926. (Courtesy Thompson family.)

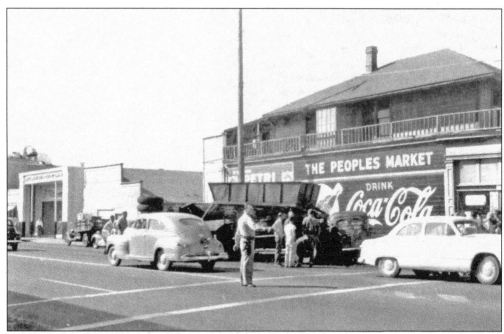

ACCIDENT AT PARKER AVENUE AND FIRST STREET. Before Interstate 80 opened, U.S. Highway 40 through Rodeo was a well-traveled route, and the curve at the north end of town was a scene of many accidents. In this case, the People's Market delivery van was crushed by a truck. The opening of the freeway eliminated the traffic but also led to a decline in customers in Rodeo's business district.

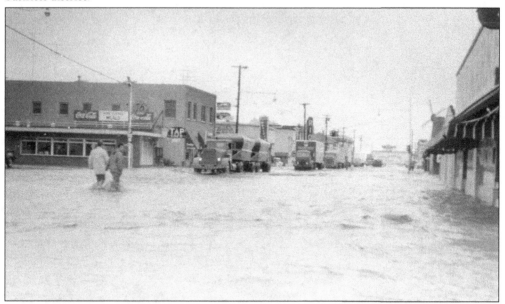

PARKER AVENUE TRAFFIC, 1958. On April 3, 1958, Parker Avenue flooding slowed Highway 40 truck traffic. Today refinery trucks are routed east to a road that connects to the Cummings Skyway and thence to Interstate 80, significantly cutting down on traffic. One motorist said that Rodeo was a town "where you used to get traffic tickets before the freeway bypass was constructed." (Courtesy Thompson family.)

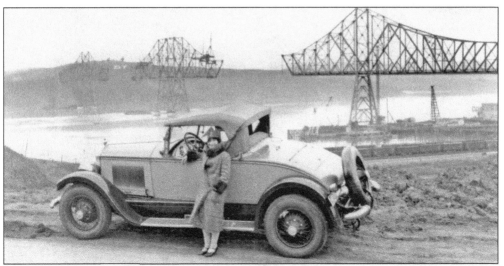

CARQUINEZ BRIDGE CONSTRUCTION, 1927. The bridge was dedicated on May 21, 1927, the same day Lindbergh completed his historic trans-Atlantic flight. It cost $7.9 million, making it the first major bridge in the Bay Area. Rodeo-Vallejo Ferry Company principals, Aven J. Hanford and Oscar Klatt, organized the American Toll Bridge Company, which obtained the franchise to build and operate the bridge. Two successor bridges (1958 and 2003) have since opened, and this bridge is being dismantled. (Courtesy Raymond L. Raineri.)

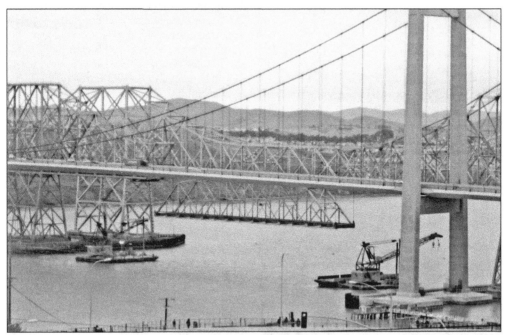

CARQUINEZ BRIDGE DEMOLITION, APRIL 2006. Two more bridges spanning the straits were built on either side of the earliest bridge, opening in 1958 and 2003. The newest bridge also accommodates pedestrian and bicycle traffic. The 1927 bridge needed to be dismantled piece by piece due to its proximity to the other bridges and because of environmental concerns. Demolition costs are more than five times the original construction cost. (Courtesy Sue Harryman.)

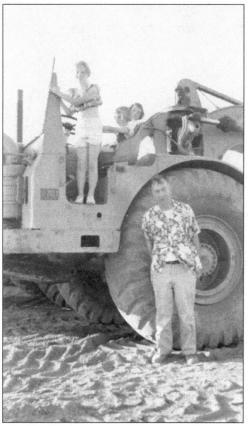

MADERIOUS BUILDING, SECOND STREET. Al Maderious paints the curb at the Greyhound bus depot outside his building that was constructed in 1946, during the post-war building boom in Rodeo. The family's dwelling, which had once sat at ground level facing Parker Avenue, was raised to the roof of this building. Note the open and unlocked newspaper rack.

THE "BIG CUT." From left to right, Carol, Sue, Ginger, and Joe Thompson explore construction equipment used during excavation of the "Big Cut" on the bridge's southerly approach. It was the world's largest at the time, involving 8,800,000 cubic yards of excavation in a cut that was 2,500 feet long, 1,370 feet wide, and, at its deepest point, 300 feet deep. (Courtesy Thompson family.)

Five

LOCAL INDUSTRY

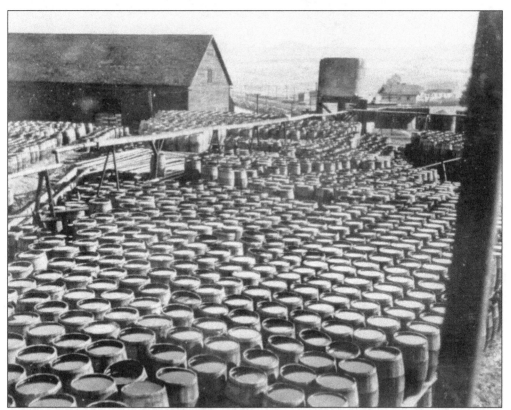

WARREN BROTHERS REFINERY, 1911. The Warren Brothers Company operated a 13-acre refinery at the Rodeo waterfront leased from Western Oil Company. In 1911, product was shipped in barrels. From a distribution center, gasoline was then delivered to stations by horse-drawn tank wagons. Part of a driver's job included bathing the horses and washing and greasing the wagons. A driver in 1911 earned about $55 a month. Other refinery lessees over the years included National, Metcalf, Sinclair, and Banner oil companies. (Courtesy California History Section, California State Library.)

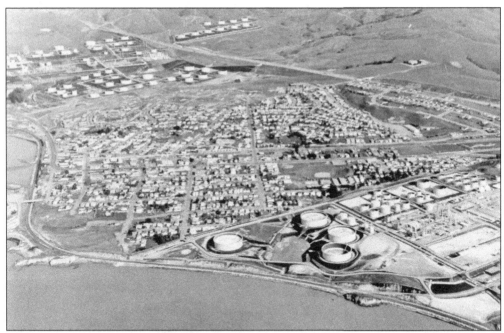

AERIAL VIEWS, FEBRUARY 1967. The Union Oil Refinery (above, in the background) at Oleum is the oldest continuously running refinery in California, begun in 1895 when 68 acres were purchased for $15,000 from the California Redwood Company. Now operated by ConocoPhillips, the present refinery operating area is approximately 495 acres with 615 acres of primarily undeveloped land surrounding it. Garretson Avenue (below), the western boundary between Hercules and Rodeo, runs from top to bottom in this view of the Sequoia Refinery at Hercules, later known as Pacific Refining Company. Refinery operations ceased in 1996, and since then, the land has been reclaimed for home sites in Hercules. (Courtesy Contra Costa County Consolidated Fire District [now Contra Costa Fire Protection District]; photograph by Capt. Aart J. Rackwitz.)

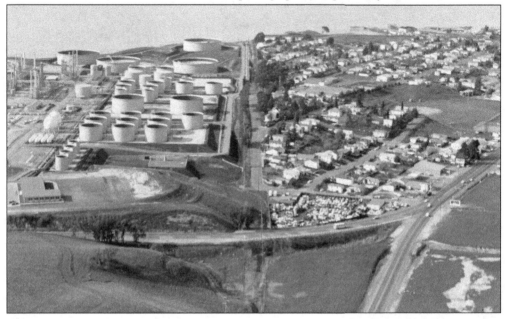

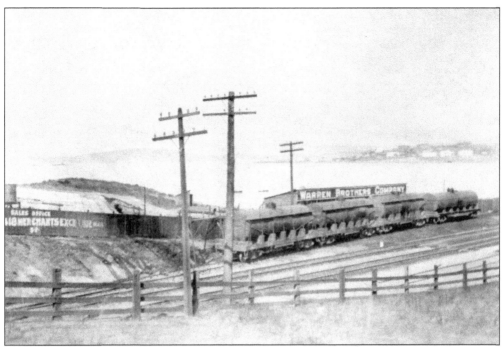

REFINERY DEPOT AT RODEO, 1911. Cars sit on the railroad siding at the Warren Brothers depot at the Rodeo Beach. The Southern Pacific station is to the right, just outside the frame of the photograph. (Courtesy California History Section, California State Library.)

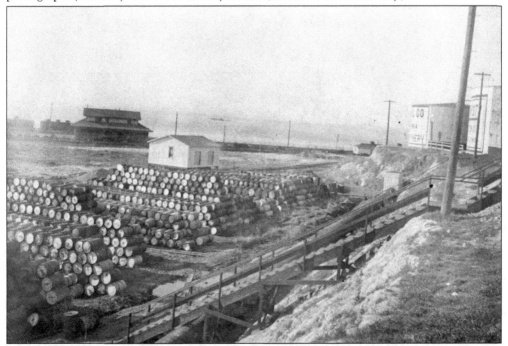

REFINERY DEPOT AT OLEUM, 1926. The Union Oil rail depot is at the top left in this 1926 image. Although a rail tank car waits at the station to transport product, much of the petrochemical product still moved in barrels.

OLEUM SERVICE BUILDING, 1926. This building, used as a rest and change house for Union employees, was northeast of the hotel shown on page 74.

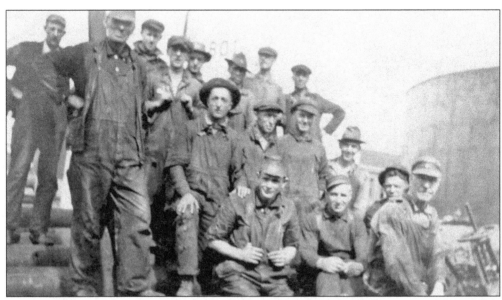

OLEUM WORK CREW. A Union Oil crew includes Manuel Sacca (second row, second from right). (Courtesy Edward Sacca.)

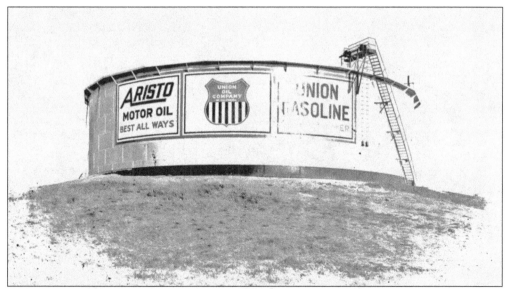

TANK AT OLEUM, 1927. Note the Union Oil corporate symbol on the tank. The shield was replaced by the 76 logo, which tied in with the slogan "Minute Man Service" used at its retail gasoline stations.

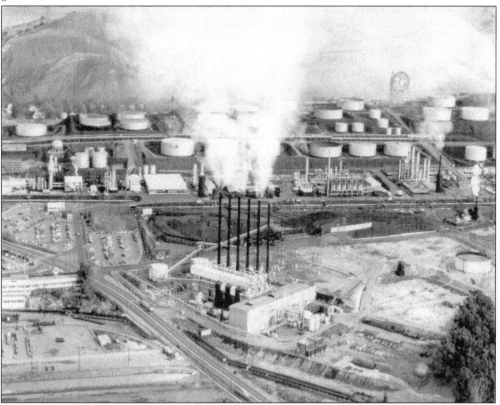

OLEUM POWER PLANT, 1967. This aerial view of Oleum was taken in 1967. At center are the six stacks of the power plant, said to be the original location of Patrick Tormey's home built in the 1870s. (Courtesy Dave Bunyard.)

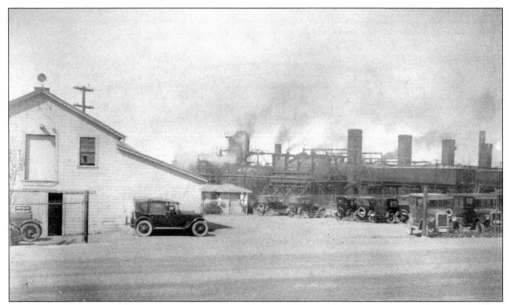

PARKING LOT AT OLEUM, 1926. The Union Oil parking lot, as it appeared in 1926, included jitneys for transporting employees around the planet. The stills shown here have long since been replaced by cleaner-burning equipment.

HOTEL AT OLEUM, 1926. The original residential hotel at Oleum was located on the northwest side of old Highway 40, where the main offices of ConocoPhillips are now located. Many refinery employees lived at the site, which made them available for quick call-up in case of emergency. Single male employees lived in the hotel and dorms, and managers lived in company houses.

OLEUM BASKETBALL PLAYER. Union employee Vernon Valerro poses in his basketball uniform. Employees also participated in tennis, badminton, horseshoe, basketball, bowling, and semi-pro baseball. (Courtesy Valerro family.)

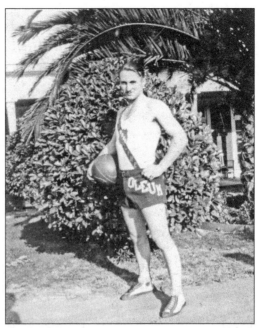

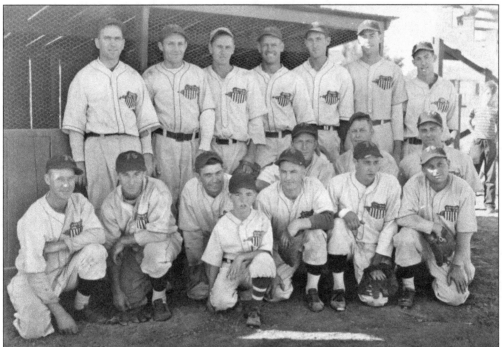

UNION OIL BASEBALL TEAM, 1940. The Oleum team won the championship of the county refinery league and the *Tribune* tournament. Names recorded on the photograph include: manager Simms, catcher Rosano, pitcher Vigre, first base Gabrielson, pitcher Berndt, pitcher LeGault, utility player McCormack, second base Olson, center field Parker, shortstop Ellsworth, third base VanArsdale, left field Maggert, catcher Pool, pitcher Peterson, catcher Gualdoni, pitcher-fielder Hardt, and bat boy David Claeys. Note the Union Oil corporate shield on the players' shirts. (Courtesy David Claeys.)

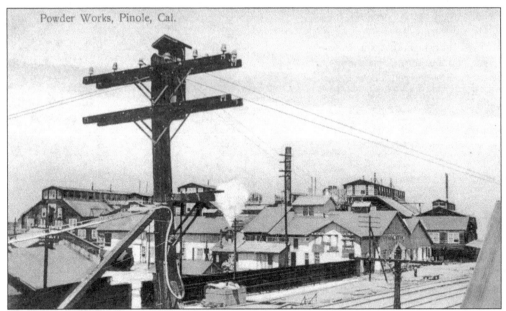

Powder Works, Pinole, Cal.

POINT PINOLE POWDER WORKS. Powder companies located in the Point Pinole–Hercules area beginning in 1881 and operated under the names Giant, Atlas, California, and Hercules Powder Companies. Hercules was one of the three largest producers of explosives in the world during World War I and supplied most of the dynamite used by the Allied forces. This postcard view was printed in Germany, a source of fine lithography until World War I ended trade with the United States.

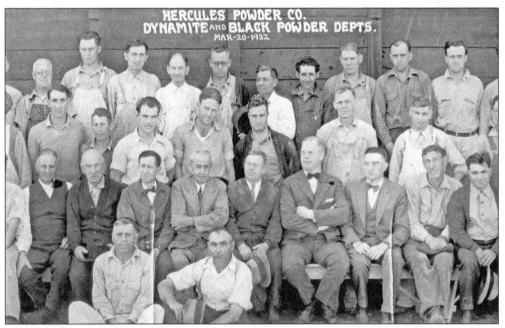

HERCULES POWDER CO.
DYNAMITE AND BLACK POWDER DEPTS.
MAR-20-1932.

HERCULES EMPLOYEES, 1932. The country was in the midst of the Great Depression when this group photograph was made. The serious nature of working with explosives is reflected in the men's faces. This photograph was taken by O'Dell Studio in Hollywood.

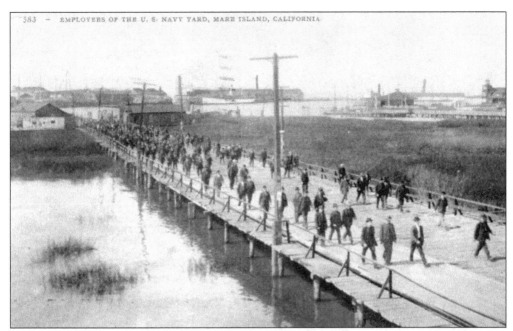

MARE ISLAND WORKFORCE. In 1854, Mare Island officially became a navy yard, the first on the Pacific Coast. More than 500 ships were built there, and some 1,200 vessels were overhauled. The yard employed many Rodeo residents among its workforce, which once numbered 41,000. Operations have since been phased out, with final closure occurring in April 1996. Here workers are seen walking to the ferry that would carry them across the 2,000-foot channel.

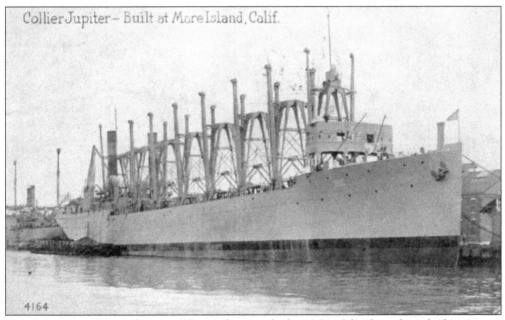

Collier Jupiter – Built at Mare Island, Calif.

4164

THE JUPITER AT MARE ISLAND. This coal carrier built at Mare Island was launched in August 1912. During its 30-year span of service, the collier was converted twice, first as an aircraft carrier and then as a seaplane tender. Hundreds died when the *Jupiter* was lost to enemy action off Java on February 27, 1942. (Courtesy Raymond L. Raineri.)

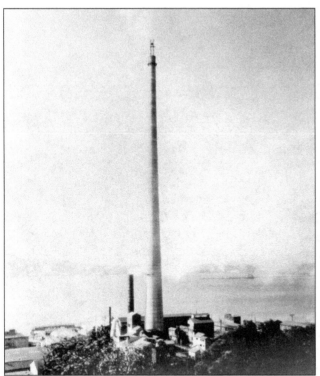

SELBY SMELTER SMOKESTACK, 1937. The smelter at Selby was established by Thomas Selby in 1884. The waterfront location was crucial in order to receive raw materials from all over the world. Construction began in 1936 on the 605-foot, 9-1/2-inch smokestack, once considered the tallest in the world. It was razed in the early 1970s, when the plant was dismantled. (Courtesy California History Section, California State Library.)

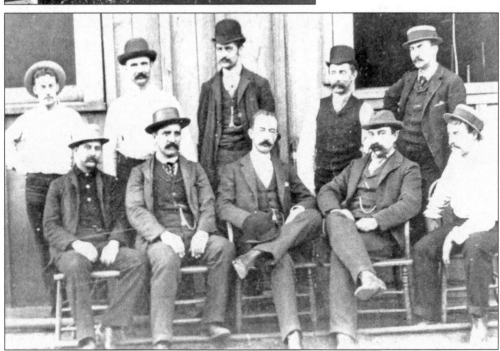

SELBY SMELTER WORKERS, 1892. Personnel of Selby in 1892 include, from left to right, (first row) William Middleton, manager T. Bee Alfred Von Der Ropp, ? Englehardt, and George James; (second row) ? Cronice, J. Campbell, A. W. Beam, ? Gumbreuer, and H. Webb. (Courtesy Crockett Historical Society, Harry Nancett Collection.)

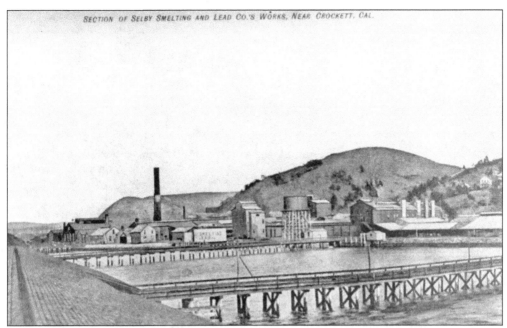

SELBY SMELTER, 1880S. The Selby Smelting Company of San Francisco established a plant in Contra Costa County in the early 1880s. Some activity continued at San Francisco until 1906, when the entire production moved to Selby. The facility was later acquired by the American Smelting and Refining Company. In 1957, 26 percent of the smelter workforce of 160 resided in Rodeo. (Courtesy Crockett Historical Society.)

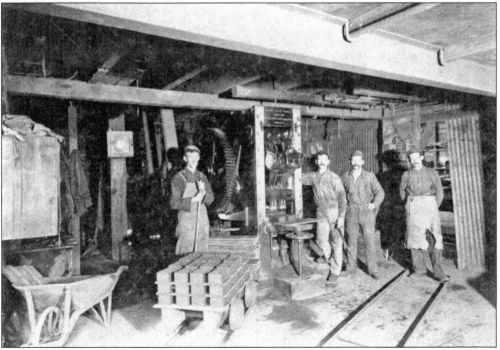

SELBY WORKERS, 1912. A work crew pauses for a candid photograph. The only identified person is Rodeo resident John Slate, second from the right. (Courtesy Gordon Lavering.)

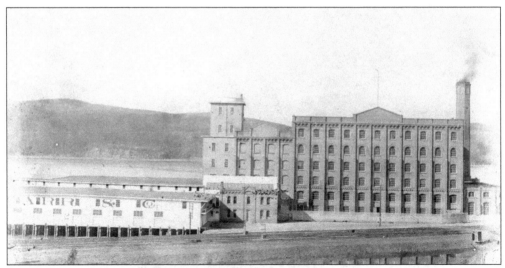

STARR FLOUR MILL, 1887. The Starr mill at Crockett, five miles from Rodeo, never met expectations and was closed in 1894, following the financial panic of 1893. These buildings were enlarged and modernized to house the California and Hawaiian Sugar Refinery. (Courtesy Raymond L. Raineri.)

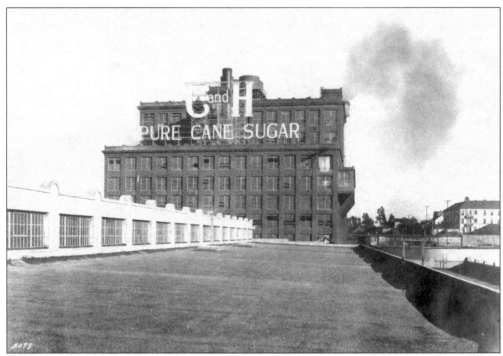

CALIFORNIA AND HAWAIIAN SUGAR REFINERY, 1923. The sugar refinery began operations in 1897, but it was not until 1906 that the plant became strictly a cane sugar refinery. The familiar C&H neon sign is seen from the Carquinez Straits side of the plant. Data from a 1957 study indicate that 16 percent of the plant's workforce resided in Rodeo. (Courtesy Crockett Historical Society; photograph by Hosmer.)

Six

THE GROWTH YEARS

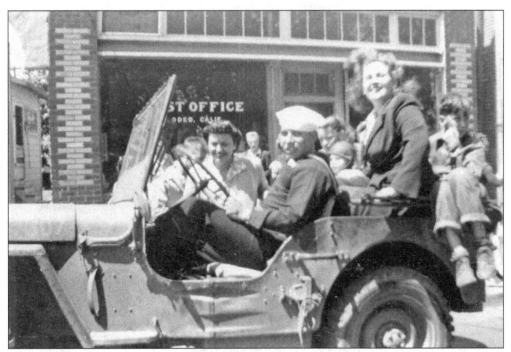

WAR-ERA BOND DRIVE, 1945. A light-hearted moment is captured outside the Rodeo Post Office at 448 First Street. John Souza is the boy riding at the rear, and Olivia Blackwood stands near the passenger seat, but the other riders are not identified. On Tuesdays, anyone who purchased a U.S. savings bond to aid the war effort got a free ride in the Jeep. This chapter covers the years of rapid growth in Rodeo following the Great Depression. To house war workers, the federal government built a large housing project on the north side of town called Bayo Vista. Shortly after World War II ended, the community turned its attention to building up the business district and expanding the housing supply. Improvements were made at the marina, and new retail stores, a bus depot, and two schools were constructed. (Courtesy Blackwood family.)

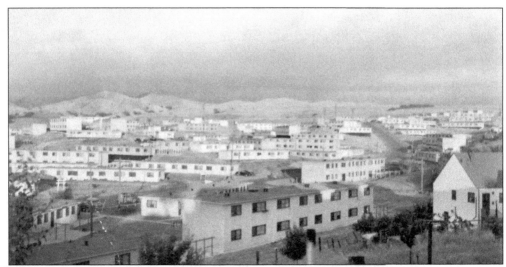

BAY VISTA HOUSING PROJECT. The $1.7-million contract to build Bayo Vista was awarded in September 1943 for 1,000 apartments intended to house Mare Island employees and their families. Road names at Bayo Vista are now nearly all lost to history, including the war heroes (Emery, Dempsey, Brennan, Austin, Doherty, Gilmore, Whitman, Duffy, Wintle and Ward Heiser) and fighting ships built at Mare Island (*Wahoo, Trigger, Tunny,* and *Tullibee*).

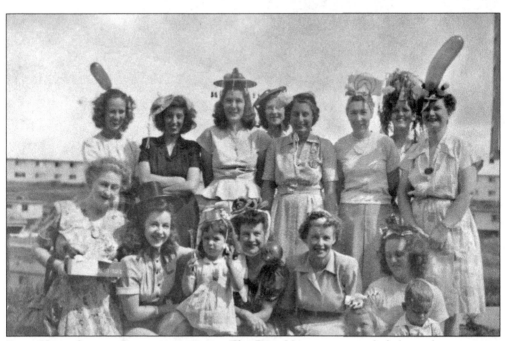

BAYO VISTA SOCIAL CLUB, LATE 1940S. The Bayo Vista project included an administration office, a child-care center, and an auditorium where many community activities took place. This late 1940s group is wearing silly hats like those worn for the Rodeo Garden Club's annual Christmas hat parade.

REFINERY VIEW, 1955. This photograph was taken from the window of Building Q-7, Apartment 986. Although all the streets had names, addresses in Bayo Vista were usually designated by building letter and apartment number. Bayo Vista closed is post office substation in 1949, when carrier delivery service began in Rodeo. (Courtesy Nowell MacArthur.)

BAYO VISTA IN TRANSITION. The wartime housing at Bayo Vista, taken over by Contra Costa County, was demolished 20 years after it was built to be replaced with a smaller number of units planned for 250 families. The newly rebuilt project was dedicated in January 1964. At that time, the buffer zone between the refinery and the town was enlarged by 60 acres.

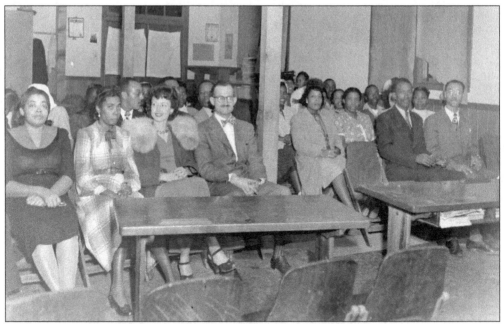

BAYO VISTA CHURCH MEETING. The Community Baptist Church was organized in 1945 by Rev. Otys D. Banks, Sr. Lillian Davis, and Sister Jenkins. It became Bayo Vista First Baptist Church in 1946. The photograph above was made *c.* 1950 in the Bayo Vista Post Office substation, which was used for church meetings and services. From left to right are (first row) Lillian Davis, Savada Banks, Velma MacArthur, Judge Donald Creedon, Rev. Cleve Porter, and Rev. Otys Banks; (second row) Henry Monte Bobo, Lloyd Williams, Namon Lewis, Evelyn Adams, and Mary Etta Harris (flowered dress). Indiana Lewis looks through the space between Lewis and Harris. Mary Bonton and baby Wendell Bonton are at the right rear. In 1985, Rev. Lonny L. Davis was instrumental in the church acquiring a former store at 632 First Street, as shown below, that was converted to a church and hall.

ST. THOMAS CHURCH, WILLOW AVENUE. St. Thomas Episcopal Church held services at the Rio Theatre before building this church. Under the direction of Vicar Lester Kinsolving, a successful building fund-raiser dinner was held with the actor and Episcopalian Robert Young as the guest of honor. Hercules Powder Company in Delaware was persuaded to sell the congregation the one-acre parcel on Willow Avenue. Full Gospel Fellowship now makes the church its home.

FIRST UNITED PRESBYTERIAN CHURCH CHOIR, 1945. The Presbyterian choir poses outside the church at Second Street and Lake Avenue. From left to right are (first row) Mrs. J. Rogers, Mrs. J. Lack, unidentified, Mrs. T. Drew, Thelma Drew, Emma Koster, Evelyn Badger, Hazel Williams, Dorothy Vaughn, Clair Wreath, and Nellie Mumford; (second row) N. Nunemann, Tomas Drew, Marg Gish, Everett Cox, Eli Vaughn, Gwen Winship, Ada Dern, Thomas Rogers, Beryl Vaughn, Georgia Ault, Shirley Carpenter, Evelyn Siebold, Dr. J. Cory, and Everil Williams (organist and director). (Courtesy Contra Costa Historical Society, Louis Stein Collection.)

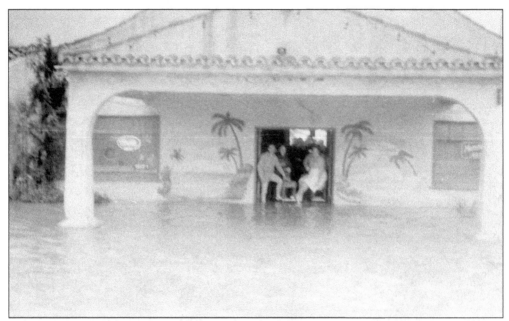

76 CLUB, APRIL 1958. Patrons await the retreat of floodwaters at the tavern named for the Union Oil brand. The bar, located on the west side of Parker Avenue just south of Third Street, had a semicircular driveway and porte cochere that gave it the appearance of a nightclub. The neon window signs are for Coors and Hamm's beers. (Courtesy Gordon Lavering.)

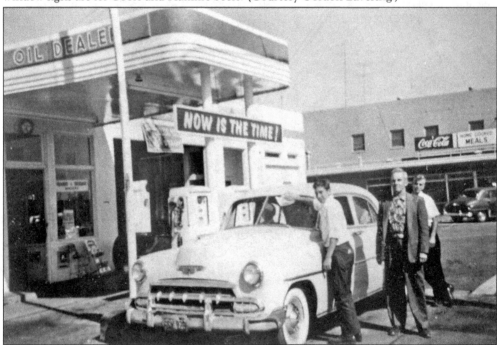

PRAIRO AND GEORGE UNION STATION. In the 1950s, the Union station at Pacific and Parker Avenues was operated by Taft Prairo and Frank George. David George cleans customer Manuel Faria's window while Art Silva, from Vallejo, watches from the rear. In the background, Jim Elkins's T-P Café sign advertises home-cooked meals. (Courtesy Werth family.)

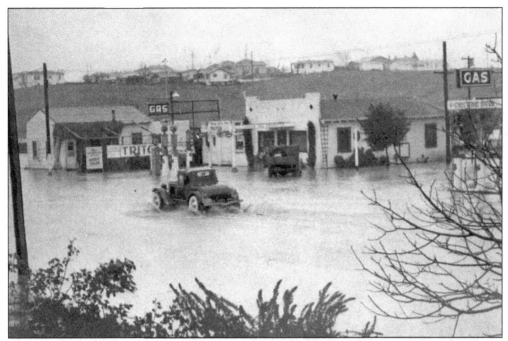

PARKER AVENUE STATIONS. The two gas stations on the west side of Parker Avenue at Fourth Street were inundated by flooding thought to have been caused by the severe storm of December 1937. John Cardoza operated the station on the left. Note the advertisement on the fence at left for Triton motor oil, a product introduced in 1934. (Courtesy Dave Bunyard.)

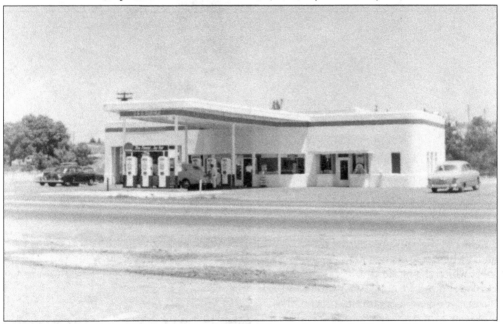

BONOVICH AND GERZ UNION STATION, 1954. The moderne-style Union Oil station was on the southeast corner of Parker Avenue and Fourth Street. Sporting goods were sold at the little retail store on the right. Frank Padilla later operated the station. It is presently a 76 outlet, but the building and pump islands have been rebuilt. (Courtesy Bonovich family.)

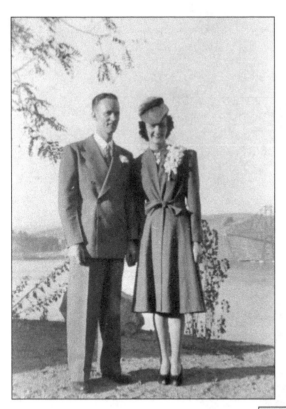

ALLAN AND FRANCES RIEMKE. The Riemkes pose above the Carquinez Straits on their wedding day in September 1940. The Crockett natives moved to Rodeo in 1958 and were owners of the Rodeo Garbage Company. Allan was active in civic projects, including the building of the Rodeo community pool. (Courtesy Anita Mann.)

CARMEN BROMLEY. Carmen worked as a welder in the shipyards during the war and, in 1948, she opened her first dress shop, which she ran until 1983. Bromley's fashion shows were done usually as fund-raising for different organizations, churches, and schools in the area. Dorothy Peck was with the shop for most of those years and was a big contributor to the success of the business. People liked Bromley's personalized attention and service.

CARMEN AND VINCENT RUGGERI. A community square dance held around 1950 brought out merchants Carmen and Vincent Ruggeri. Vincent, a native of Italy who came to the United States at the age of 17 months, was a graduate of the University of California pharmacy school and was a practicing pharmacist for 50 years. The Ruggeris' first Rexall pharmacy was at 530 First Street before moving to a larger store at 199 Parker Avenue.

JAMES DRENNAN. Also at the Rodeo square dance was James Drennan, owner of the watch repair and jewelry shop called the Tic-Toc. Drennan came to California from Illinois in 1940 to work at Mare Island. In 1947, he opened his store. Drennan served as officer of both the Rodeo Chamber of Commerce and Lion's Club. His wife, Marcella, taught elementary school in Rodeo.

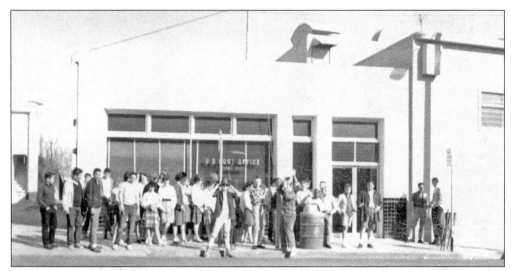

POST OFFICE, 1963. A Garretson class visits the post office. This moderne-style building was constructed in 1949, the same year that home delivery began in Rodeo (July 1, 1949). Following a bidding process that began in 1969, the post office moved to new quarters on Parker Avenue in 1975.

PACIFIC AVENUE, 1941. The street is relatively undeveloped in this view from Pacific Avenue looking across Parker Avenue toward St. Patrick Church. Flippy's Restaurant (formerly the Burger Villa) replaced the corner gas station in the early 1960s. (Courtesy Ginochio family.)

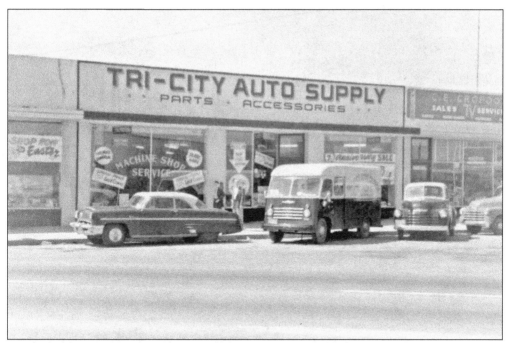

TRI-CITY AUTO SUPPLY, 1954. One of the first tenants in the Claeys building on Pacific Avenue was Tri-City Auto, established by John Pereira, Al Rodrigues, and Edward Sacca in 1947. The three men all grew up in Rodeo, graduated from John Swett High School, and were World War II veterans.

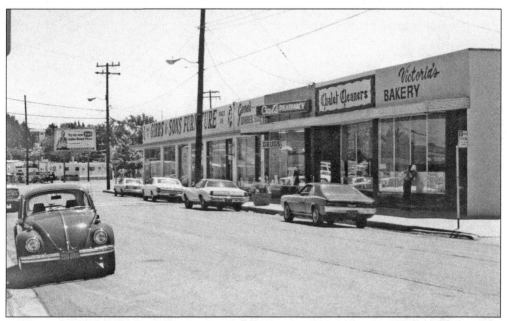

PACIFIC AVENUE, 1978. In 1978, the tenants in the Claeys building on the west side of Pacific Avenue (from left to right) included Gibbs Furniture, Gene's Barber Shop, Cal's Pharmacy, Chalet Cleaners, and Victoria's Bakery, formerly Carmen Angotti's bakery and now El Sol restaurant.

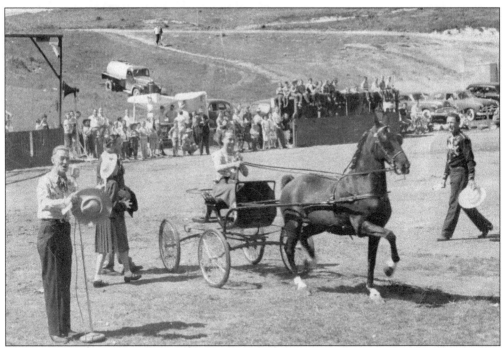

RODEO AT GARRETSON FIELD. The Rodeo Boosters Club sponsored this event around 1949 or 1950. Above, Leona (Dickinson) Bonovich drives the buggy, while her husband, Steve Bonovich, with hat in hand, strides toward the horse. Leona drove pacers and trotters competitively, while Steve trained horses. At the microphone is Boyd Radar, an employee at the Bonovich Ranch. Leona was a teacher, and after retirement once held the distinction of being the oldest substitute teacher in the state. In the photograph below, Garretson School looms above the field.

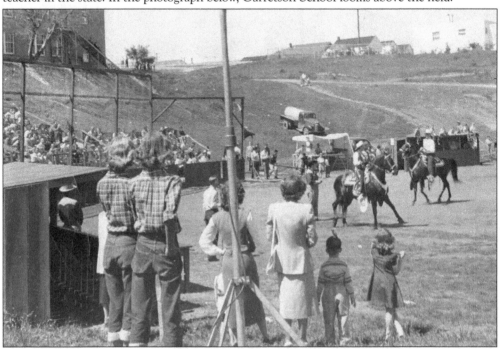

PARKER AVENUE BURRO, C. 1960. The barefoot rider has greeted visitors to Rodeo for six decades. The folk art was sculpted by Alibrando Orsi in 1941 at his home on Garretson Avenue and was moved to its present location at 545 Parker Avenue in 1947. Orsi's grandsons, Robert Parini (left) and David Orsi, are shown here. Sculpter Orsi, a native of Lucca, Italy, who owned olive orchards in Italy, worked in lumber camps and gold mines in this country before hiring on at California and Hawaiian Sugar in Crockett. The burro is one of his many creations, which included birdbaths, animal sculptures, religious-themed reliefs, and busts of Roosevelt and Kennedy, plus a mermaid fountain that resides at the former Bennett's Marina. (Courtesy Orsi family.)

ENTERTAINMENT ADVERTISEMENT, 1950. The Top Hat and 76 Clubs sat side by side on Parker Avenue.

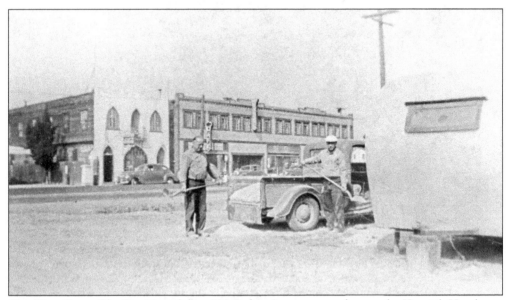

TOP HAT CLUB. The Top Hat Club at 330 Parker Avenue, next door to the Kronick Hotel, was one of more than a dozen bars in Rodeo, mostly located on Highway 40. In this view, the hotel is the brick building at right and the white structure with the Gothic-styled window and door openings is the Top Hat Club. (Courtesy Werth family.)

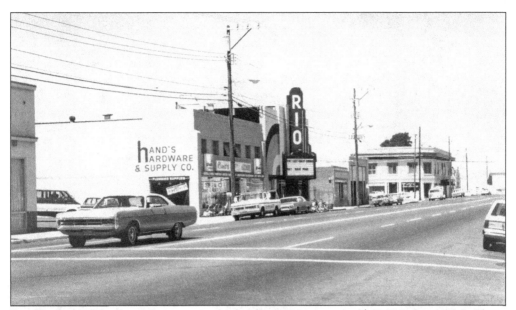

RIO THEATRE. The theater was constructed in late 1940 at a cost of $60,000. Owner S. J. Claeys initially leased it to operator Cecil Pace. Subsequent managers included Harry Weaverling and Val Winkel. It became a concert venue (as shown here) and now houses a church. The hardware store at left had replaced what had once been the Rodeo Mart and later Scharlin Brothers Department Store, selling clothing and furniture.

RIO PROGRAM, 1944. Into the 1950s, theater promotions included free china for ladies on Tuesdays and Wednesdays, free turkeys at Thanksgiving, and stage contests, all audience-builders left over from the Depression era. *Film Daily Yearbook* gave the seating capacity as 400 to 425. The previous theater, the Rodeo located one block to the north, accommodated only 200 people.

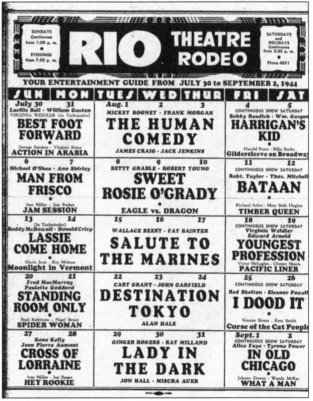

FOUR-O-ONE CLUB, FIRST STREET. The Pacheco store (see page 22) at 401 First Street became a bar known as the Four-O-One Club under the management of Joaquin Pacheco, shown here second from left. Rose Pacheco is at the left, Jiggs Madden (who later owned the Marquee bar) is second from right, and the woman at the far right is unidentified. (Courtesy Frankie and Judy Adams.)

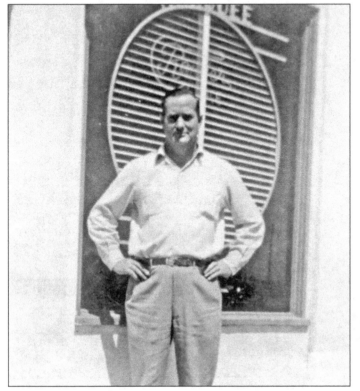

MARQUEE BAR, PARKER AVENUE, C. 1940. Shown here is Neil Peck, who with partner George Crofoot, opened the Marquee in the former Rodeo Theatre. Rodeo had a large number of bars relative to its population size due in part to its location on Highway 40 and because many merchant sailors and industrial workers passed through the area. (Courtesy Arlene Krager.)

WINDMILL CLUB, PARKER AVENUE.
Manuel Fernandez began the Windmill
Club as a soda fountain and restaurant.
The name was a reference to the fictional
Don Quixote, who tilted at windmills in
the same way that Fernandez stood up
to the opposition when he was a labor
organizer in his native Portugal. When
Prohibition ended, the Windmill was
able to sell liquor, and in 1950, dancing
to a four-piece band and shuffleboard
were offered.

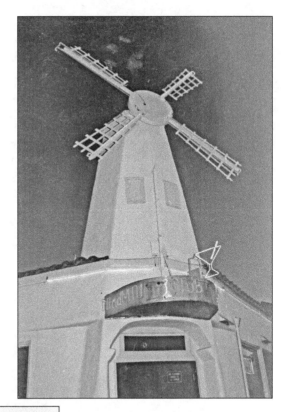

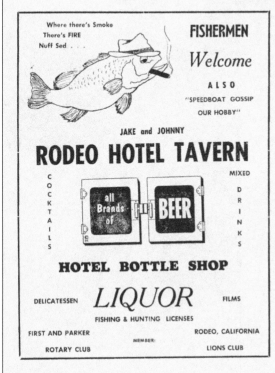

**RODEO HOTEL TAVERN
ADVERTISEMENT, 1958.** The hotel
on the southeast corner of First
Street and Parker Avenue sat at
the northern gateway to Rodeo. A
longtime owner was the popular Jim
Guthrie. Ask longtime residents
about Rodeo, and they remember the
many bars: the Camel Club, Troy's,
Aleman's, Marquee, Snug Harbor,
Top Hat, 76 Club, Pilot House,
Highway 40, the Club, Brownie's Pool
Parlor, Sunset Tavern/Lakeman's,
and Ray's to name a few. (Courtesy
Dave Bunyard.)

MELLO FAMILY. Siblings (from left to right) Ansel, Clara, and Mary Mello pose in front of the family home at 364 Garretson Avenue. In 2006, Mary was given a lifetime achievement award by St. Patrick Church. Mary, who worked for 47 years at the sugar refinery in Crockett, volunteered thousands of hours at the rectory in parish festivals, bingo games, and the school library, and even found time to sing in the choir for more than 30 years. (Courtesy Mary Mello.)

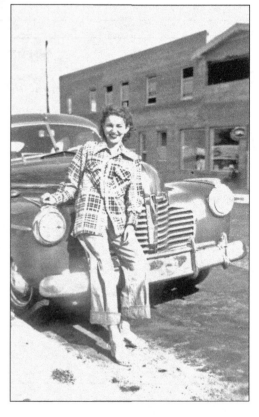

OZELLA SHARP SLATE, 1947. Happy days are here again. The war is over, but Ozella Slate's outfit is a reminder that slacks became popular for women during the war years, when they took jobs in industry. Ozella held a "Rosie-the-Riveter" job in the Richmond shipyards. The Maderious Building, still under construction in the background, is part of the post-war building boom. (Courtesy Ginochio family.)

MARQUEE BAR EXTERIOR, 1947. Roy Slate, at right, poses with an unidentified friend in front of the Marquee, which was co-owned by his brother-in-law. This business is now Ricky's Corner, a bar and restaurant.

TOWN OF RODEO, EARLY 1950S. In this aerial view, the pier and boat sheds at Joseph's Resort are visible at the top center of the photograph, but Bennett's Marina (top right) had not yet taken shape. The diagonal street is Pacific Avenue, stretching between the marina and Parker Avenue. (Courtesy David George.)

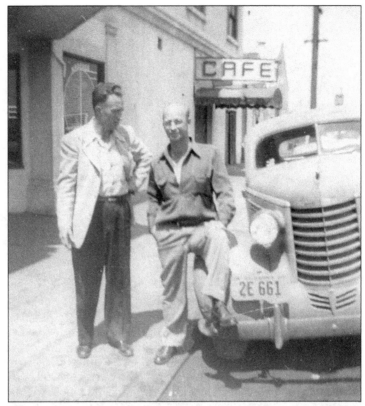

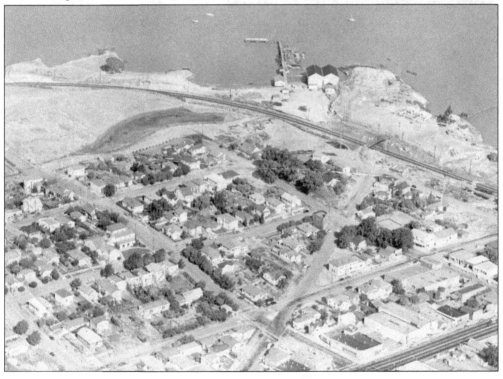

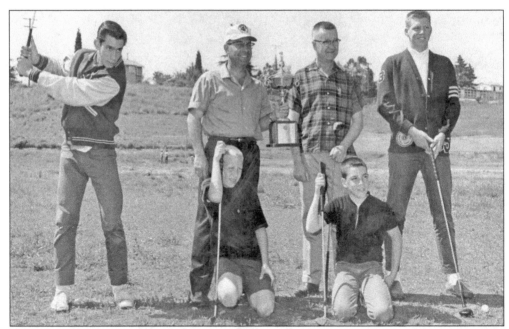

HOLE-IN-ONE CONTEST, 1963. The Lion's Club hole-in-one contest offered money, trophies, and 60 other prizes to the winners. Standing from left to right are Bobby Bonovich, John Swett High student; Johnny Pereira, general chairman of the tourney; Cy Hegstrom, committee member; and Bob Neubacher, student body president at John Swett High School. Kneeling in front are Jimmy Mower (left) and Butchie Pereira. (Courtesy Robert G. Bonovich.)

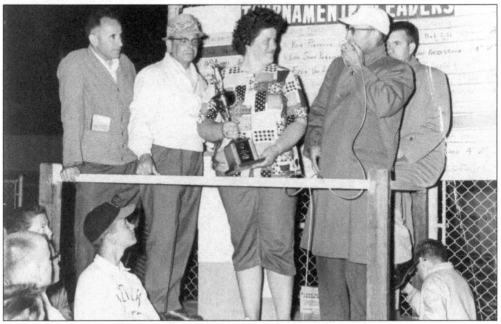

HOLE-IN-ONE PRIZEWINNER. On stage from left to right are Vernon Fereria, Del Kramer, Pat Bratton, and John Pereira (at microphone). At lower left is Richard Rose (in hat). The winning categories included most accurate student, most accurate man, hole-in-one, and most accurate woman. (Courtesy Pereira family.)

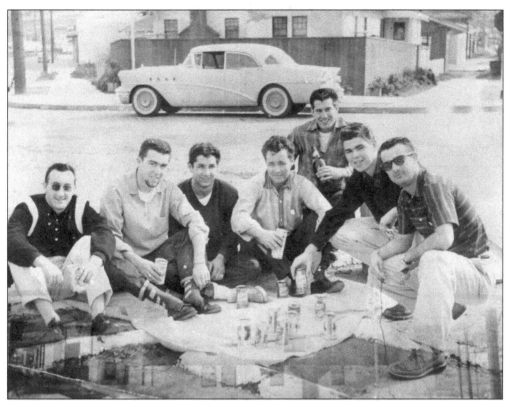

PARTY AT THE "Y," C. 1957. The Y-intersection at Pacific and Rodeo Avenues was the spot for an impromptu party and other playful mischief. From left to right are Bud Maderious, Art Hallissy, Raquel Benavidez, Jim Brownlee, Ray Formosa (rear), Jerry Johnson, and George Serpa. George, who was on leave from the army, holds the shutter remote control in his right hand. (Courtesy George Serpa.)

BOWLING TEAM. Posing at Joseph's Resort, sponsor of a bowling team, are, from left to right, (first row) George Bonovich, Fred Canziani, and Joe Bettencourt; (second row) Manny Joseph, Bob Blackwood, Vince Bonovich, and Frank Joseph. The team often bowled in Vallejo at Lucky Lanes. In the 1950s, the Bonoviches entered bowling tournaments all over the state. George had a 200-plus average for several years. (Courtesy Blackwood family.)

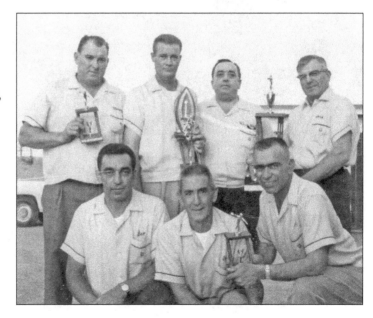

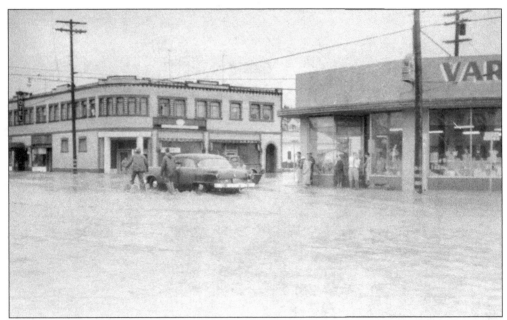

G&G VARIETY, PARKER AVENUE, 1958. Floodwaters threaten the Whitlock family's G&G Variety store during the April 1958 flood. The store was the first tenant at this location when the Claeys Building opened in March 1947. G&G carried sewing needs, stationery supplies, house wares, toys, party goods, and gifts. Advertisments in the *Tri-City News* boasted it was "the store of 1,000 items." (Courtesy Thompson family.)

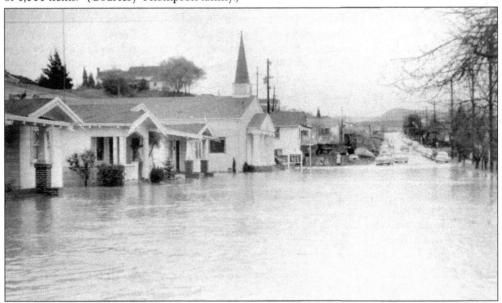

THIRD STREET FLOOD, 1958. Streets around the First Southern Baptist Church at Third Street and Vaqueros Avenue were inundated by a flood called the "worst" by the *Contra Costa Gazette*. Gov. Goodwin Knight requested that President Eisenhower declare the county a disaster area after 1,000 homes were flooded, causing $3 million in damages. In 1992, the Trinity Faith Baptist congregation acquired the church and has since completed many renovations, including the removal of the spire.

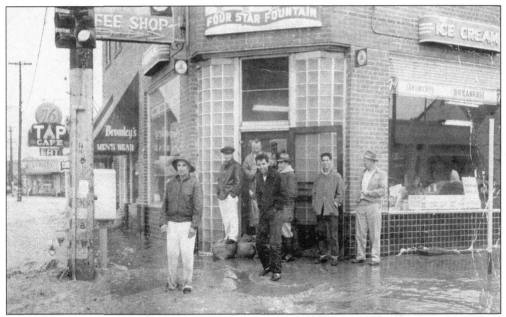

DAIREE MAID, APRIL 1958. Floodwaters back up to the door of the Dairee Maid restaurant at Parker Avenue and Second Street. From left to right are Al Maderious (building owner), Bud Maderious, unidentified, Frank Cardoza, unidentified, Ruben Salcido, and unidentified. The Dairee Maid featured dairy treats served at a horseshoe-shaped counter. Today storms are monitored closely by data fed to Contra Costa County Public Works from a rain gauge installed on the roof of the fire station on Third Street. (Courtesy Tito Moreno.)

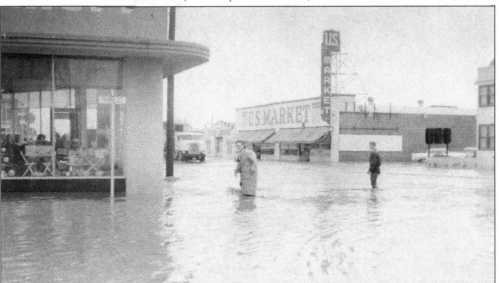

U.S. MARKET, PX FOODS, APRIL 1958. The Tanovitz-owned market at 223 Parker Avenue (also called 20th Century Market and Pacific Foods) included a fountain, drugstore, and meat market. Its slogan was "a fast penny is worth more than a slow nickel." To reduce the flood hazard, in cooperation with the U.S. Army Corps of Engineers, the Contra Costa Flood Control and Water Conservation District in 1965 acquired 51 creek-side properties in advance of improvements to Rodeo Creek, which is a block behind the store. (Courtesy Thompson family.)

MEDICAL OFFICES, RAILROAD AVENUE. Dr. S. N. Weil came to Contra Costa County in 1925 as plant physician for American Smelting and Refinery Company and then began his own practice in Rodeo. Other medical practices on Railroad Avenue were opened by physicians Gerald J. Petrone and Kenneth E. Stemmle and dentist Alan McDowell.

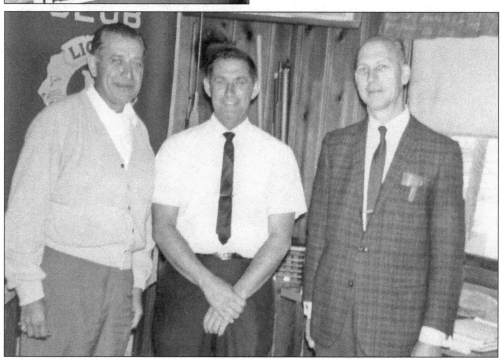

SCHOOL LEADERS. John Laznibat (left), principal at both Hillcrest and Carquinez Schools; Glenn DuFour (center), John Swett District superintendent; and George Schandelmier (right), who filled various roles as principal at Garretson and Hillcrest Schools and one-time superintendent in Rodeo, are together for an appearance at the Rodeo Lion's Club. (Courtesy Robert G. Bonovich.)

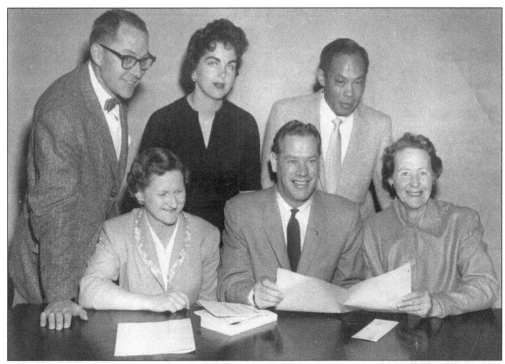

RODEO CHAMBER OF COMMERCE. A chamber committee in an undated photograph includes, from left to right, (first row) unidentified, Jim Keys, and Helen Weil; (second row) Will Cluff, Marilyn Canetta, and Al Wong.

CAL'S PHARMACY, PACIFIC AVENUE. Pharmacist Calvin R. Mower poses in his store at 228 Pacific Avenue with Mrs. Esponoza. Mower earned a degree in chemistry and went to work for Chevron. A career change led him to acquire his drugstore business in 1951. After 25 years in business, he was chosen as Person of the Year by the Crockett-Rodeo Chamber of Commerce. Longtime employees were Julia Cardoza and Rose Rodrigues. (Courtesy Calvin R. Mower estate.)

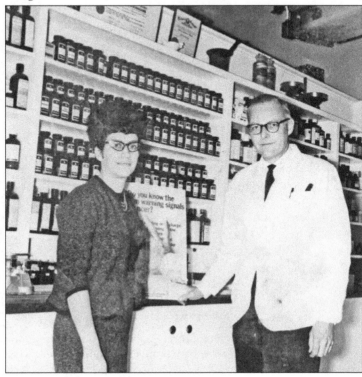

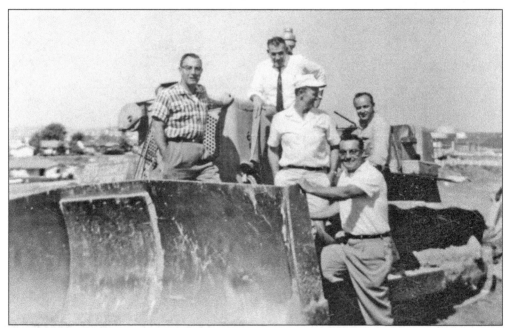

RODEO SWIMMING CLUB, 1960. Those present at the groundbreaking for Rodeo's new club swimming pool included, from left to right, treasurer John Pereira, Burt Engrahm, president Allan Riemke, John Balmino, and contractor Dale Long. The club purchased the parcel on Laurel Court from the Rodeo Highlands Company in August 1960. (Courtesy Frank and Sheri Silva.)

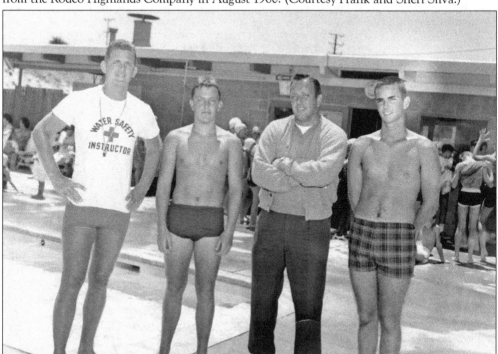

VARIED PROGRAM. The swimming club offered lessons, lifesaving courses, competitions, and recreational swimming. Shown here from left to right are coach Bob Thomas, Danny and Bill Cross, and assistant instructor Rich Riemke.

FASHION SHOW, 1961. The opening of the pool was celebrated on July 7, 1961, with a fashion show organized by Bromley's Dress Shop. The bathing-suit models are, from left to right, unidentified, Shirley Padilla, unidentified, Sandy Nichols, Sylvia Smith, Diane Lewis, Joanne Johanson, Marcia MacArthur, Sandy Boyd, Beverly Bovo, Susan Zalba, Tina Shelton, and Kathleen McEntorffer. (Courtesy Calvin R. Mower estate.)

RECREATIONAL SWIMMING. The pool had a deep area roped off for diving and a separate pool for toddlers, but these children are enjoying recreational swimming, sometimes staying all day. Females were required to wear bathing caps to keep hair out of the pool's filtration system.

HIGHLANDS REAL ESTATE ADVERTISEMENT, 1960. There were 195 lots in the Rodeo Highlands tract, which was gradually filled up with custom-built homes. The tract had been planned to be more than double the size but was reduced to accommodate the construction of Interstate 80.

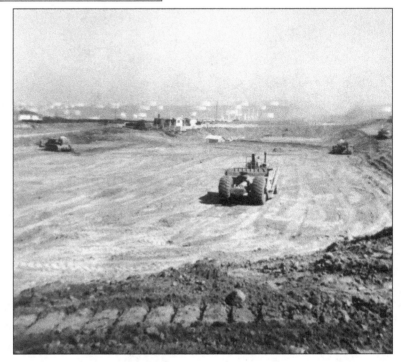

RODEO SWIMMING CLUB POOL PARCEL. The 3.86-acre parcel for the Rodeo Swimming Club pool is on Laurel Court. A current proposal would add homes to the rear portion of the parcel.

Seven

BASEBALL TOWN, U.S.A.

RODEO BASEBALL TEAM, 1964. Rodeo sent its team to the 1964 Bronco World Series in Rockford, Illinois. The players placed second in the United States, with the score at the deciding game Birmingham 2, Rodeo 1. From left to right are (first row) Ted Lettich, Dave Eyler, Tim Blotzer, Ted Chavez, John Simon, Robie Mickles, Newell Schandelmier, and Bill "Choo-Choo" Cianciarulo; (second row) manager George Serpa, Mike Joseph, Butch Pereira, Steve Falkenstein, Clyde Woods, Darren Crise, Steve Mathis, Lewis Vanmatre, and coach Manny Joseph. This photograph was autographed by professional player Stan Musial and actor Joe E. Brown. (Courtesy Newell Schandelmier.)

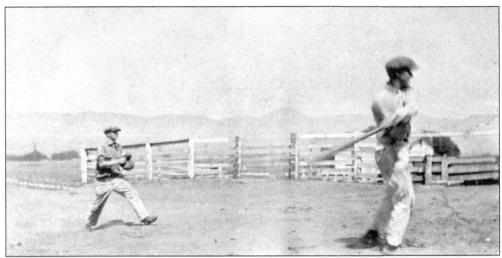

BASEBALL, 1924. This image shows a baseball game in downtown Rodeo. Indian Peak, in the background, is a local geologic feature located on the Claeys Ranch. (Courtesy Valerro family.)

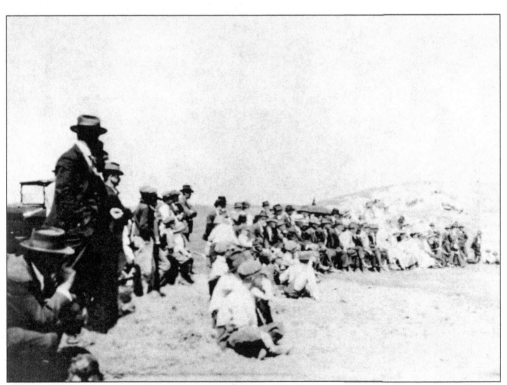

PARK AT VAQUEROS AVENUE AND MARIPOSA STREET, 1924. A crowd watches a baseball game at a diamond near Vaqueros Avenue and Mariposa Street. The rock formation in the background is at the end of Vaqueros Avenue, near the neighborhood denoted as Portugal Hill in the 1920 United States Census. (Courtesy Marlene Nancett.)

ANNUAL BALL, 1906. A dance sponsored by the Rodeo Baseball Association was scheduled to occur days after the big San Francisco earthquake. Decades later, this forgotten 15- by 22-inch poster was found by Burt and Helen Engrahm as they cleaned out a former bar at Parker Avenue and First Street. Michael Del Monte, the floor manager, was a partner with his father in the Del Monte Hotel. Since 1906, baseball in Rodeo has been played under the sponsorship of various school and community leagues. (Courtesy Frank and Sheri Silva.)

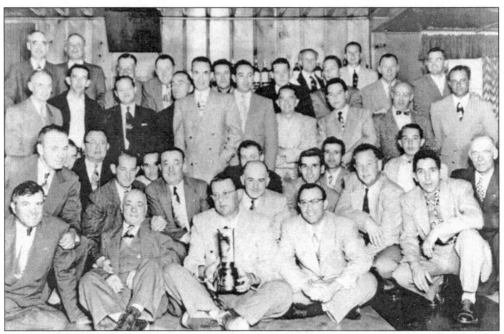

VERNON GOMEZ DINNER. Local men gather for a stag dinner at Joseph's Resort with Rodeo's favorite son, known as "Lefty." Gomez is at center, holding the blender. In the 1920s, when some of these men were boys, they played ball with Gomez. (Courtesy Pereira family.)

LEFTY GOMEZ MONUMENT. The New York Yankees contributed to a monument to honor their former pitcher, who grew up in Rodeo. Lefty's widow, the actress June O'Dea, threw the ceremonial first pitch at the dedication held in 1990, with former New York Yankees announcer Mel Allen as master of ceremonies. A monument of black jade granite is inscribed with a laser photograph of Lefty, and at its base sits the concrete step from his family's home, where Gomez placed his left handprint on November 22, 1932. (Courtesy Jerry Johnson.)

VERNON "LEFTY" GOMEZ. In 1928, Gomez began his professional career in the Utah-Idaho League, then went to the Pacific Coast League's San Francisco Seals and, in 1930, was sold to the Yankees at age 21 for $35,000. Gomez was elected to the Baseball Hall of Fame in 1972 after a major-league career of 189 wins with the New York Yankees, for which he played through 1942. Gomez saw four seasons in which he won 20 or more games, along with a 6-0 record in World Series play. (Courtesy Jerry Johnson.)

"RODEO KIDS" PARTY. "Lefty" Gomez returned to town for a "Rodeo Kids" party in the early 1970s. He had good memories of growing up in Rodeo and always remained loyal to his hometown. He was called "one of the happier, more colorful souls on the landscape: the Singular Señor and El Goofy." From left to right are Velma Dowling, June and Lefty Gomez, and Emily "Ditty" Shearer.

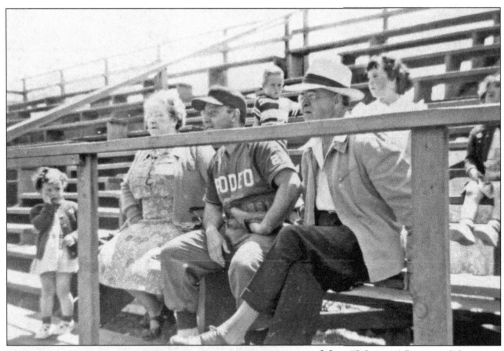

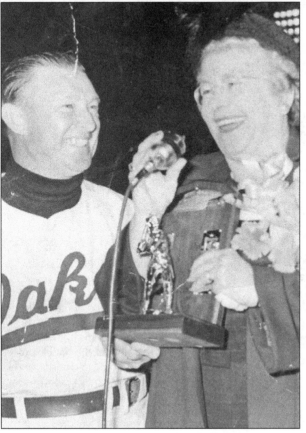

MAE "MAMIE" JOSEPH. Mamie Joseph, an enthusiastic fan of baseball, is shown above with her granddaughter Rae Blackwood, John Pereira in uniform, and her husband Fred Joseph. The *Tri-City News* wrote, "Her voice had the authority of a foghorn and carried into the next league. Hot dog and popcorn vendors were hushed in envy." In the photograph at left, on August 17, 1949, Oaks manager Charles "Churck" Dressen honors Mamie before a crowd of 12,000. She was a fan of Pacific Coast League baseball who rooted for the San Francisco Seals, but she was friends with Dressen and Oaks players Lefty O'Doul, Casey Stengel, and Cookie Lavagetto. In Rodeo, the field at Bayo Vista was dedicated in her honor on August 1, 1964. The park, constructed by contractor Dave Biddinger, featured a two-story building with a refreshment stand, restrooms, a meeting room, a press box, and storage areas. (Courtesy Blackwood family.)

LIGHTING INSTALLATION, 1956. Lighting for Garretson Field was authorized in 1956. In the previous year, three dances were held to raise funds for the project. Chairman of the committee John Pereira, squatting at front left, assists in the installation of the nine light standards. Over the years, the field has seen many face lifts and lighting upgrades. Since 1963, the Rodeo Baseball Association oversees pony-league play at the field. (Courtesy Pereira family.)

BRONCO TOURNAMENT, 1963. Coach and president of the Rodeo Baseball Association George Serpa is shown with the 1963 Rodeo Bronco team at Craghead Field in Pocatello, Idaho. The Rodeo Baseball Association participated in Bronco tournaments with teams all over the United States. Elimination tournaments at the local level were often hosted by Rodeo, which brought much activity to town. In 1963, Rodeo advanced to the divisional level, where the team played regional winners from Western states at Idaho. (Courtesy George "Lefty" Serpa.)

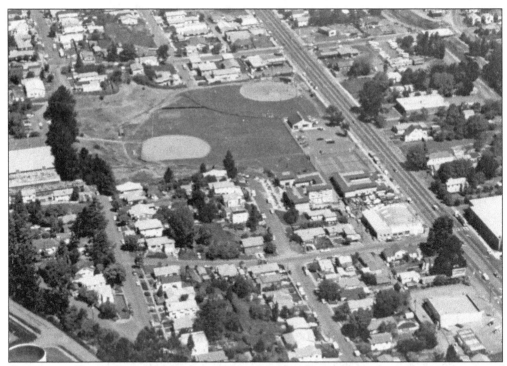

GARRETSON FIELD, 1985. Mal Decker and Jerry Johnson devoted many hours to maintenance of the ball field in this 1985 aerial view. The park became a State of California Point of Historical Interest in May 1991. The honor was granted in recognition of the place where Lefty Gomez played as a young man, and it is currently Rodeo's main recreation site and a focal point of civic pride for the town. (Courtesy Jerry Johnson.)

RODEO BASEBALL PARADE, 1991. The tradition of Parker Avenue parades continues following the annual pancake breakfast to celebrate the beginning of the baseball season. Don Smith leads the Shetland players (five to six year olds). Under sponsorship of the Rodeo Baseball Association, pony-league baseball includes about 350 players organized into teams by two-year age brackets. (Courtesy Jerry Johnson.)

Eight

THE MARINA

A RODEO LANDMARK. One of Rodeo's best-known landmarks, the big fish sign, sits at the curve of Parker Avenue. On weekends, in the heyday of fishing on the bay, cars lined up on Parker Avenue beyond the fish sign waiting to cross the railroad bridge that leads to the marina.

AQUATIC FESTIVAL, 1956. Boat racing was part of the fun at the Aquatic Festival. Participants launched from the swimming beach at Joseph's Resort in the mid-1950s.

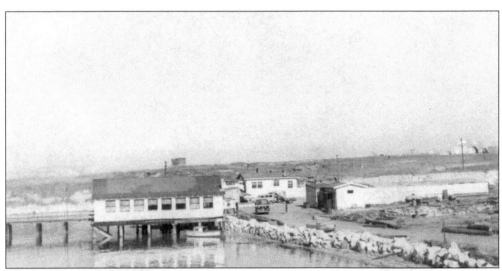

JOSEPH'S RESORT. The Josephs' fishing resort dates to 1930s. This is a 1941 view of the tavern on the wharf at left and the Joseph home at center. Owners Frank A. and Josephine Joseph (née Hurley) offered boats for rent, boat launching, pier and rock fishing, swimming, and picnicking. Frank Joseph was also active in civic affairs and was elected president of the Rodeo Chamber of Commerce in 1957.

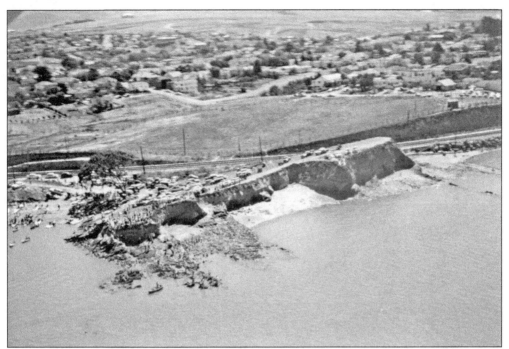

RODEO SYNCLINE, 1956. Exposed fossil beds appear in several places in Rodeo, but none is more dramatic than the stratified rock beds (syncline) at Rodeo Beach. In February 1954, *Sunset* recommended Lone Tree Point as a good site for viewing deposits of fossils, especially mollusks, sand dollars, and sea urchins. Today the East Bay Regional Park District oversees the 10.13-acre site at Lone Tree Point. (Courtesy Edward Sacca.)

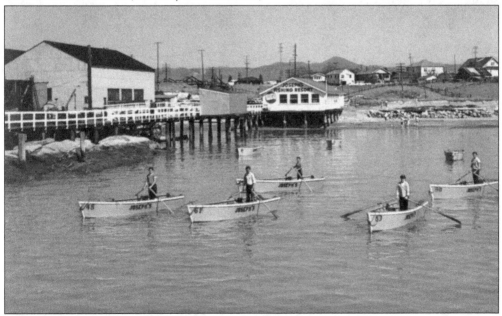

JOSEPH'S BOAT RENTALS. The Josephs operated a resort for 37 years. This photograph of Rodeo boys in the rental boats includes, from left to right, Butch Sassett, Ron Fowble, Dan Lambert, Don Thompson, and Buzz Thompson. (Courtesy Joseph family.)

JOSEPH'S PIER. The pier was a beehive of activity on weekends, especially during the bass fishing season. In the foreground is the author (at left) with her mother, Velma Dowling, c. 1956.

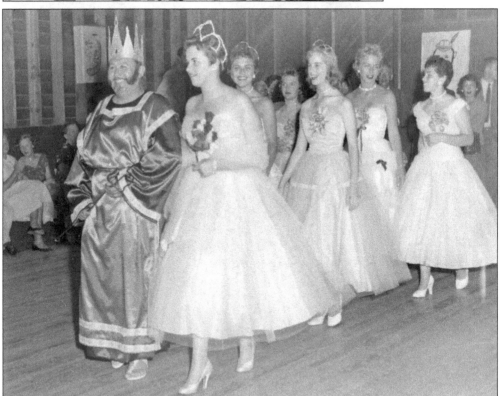

KING NEPTUNE, SEPTEMBER 1956. King Neptune, August "Augie" Hemenez, and Queen Rosemary Lambert lead the procession at Rodeo's first aquatic festival jointly sponsored by the chamber of commerce, Rodeo Athletic Club, and Rodeo Bass Club. The court members are, from left to right, Torchy Thornberry, Karen Bagley, Carla Sequest, Vicky Johanson, and Gail Reynolds. The two-day event also included a carnival, a beard-growing contest, a four-hour outboard racing regatta, and a parade. (Courtesy Richard Hemenez; photograph by George Serpa.)

BASS DERBY, 1956. The Rodeo Bass and Sportsmen Club, founded in 1936, held an annual bass derby from 1953 to 1994. This is a bass derby winner from 1956 posing with King Neptune, Augie Hemenez. The top prize of $150 was won by Joe Kohlede of Lafayette, who landed a 40-pound striper. The second- and third-place winners hauled in 35- and 22-pound bass. (Courtesy Richard Hemenez; photograph by George Serpa.)

SPORTFISHING, 1964. At Joseph's Resort in April 1964, Bill Haggart (left) and Bob Blackwood proudly display a 160-pound sturgeon measuring 7 feet, 10 inches in length. (Courtesy Blackwood family.)

BEARD-GROWING CONTEST, 1956. The first annual aquatic festival in 1956 included the Whiskerino, a beard-growing contest. Men who did not have facial hair were snared and locked up in Neptune's Brig, shown here. It was all in fun. (Courtesy Edward Sacca.)

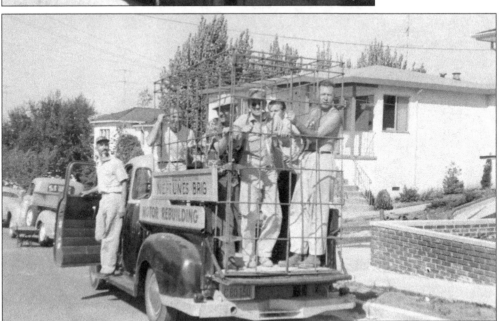

NEPTUNE'S BRIG, 1956. This is the Neptune's Brig "paddy wagon" piloted by Ed Sacca, who "arrested" clean-shaven mean. The "prisoners" were paraded around town, sprayed with water, and fed bread and beer. Bob Dern (left) and Ed Dowling are at the rear of the truck, and Bill Dowling is behind the driver's seat, having been arrested on Vallejo Avenue in the midst of helping his brother Ed do yard work.

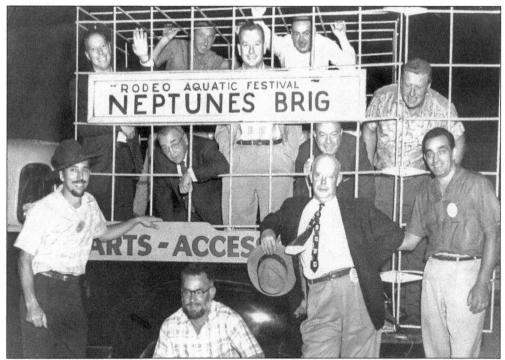

NEPTUNE'S BRIG, 1957. Posing for a publicity photograph are, from left to right, (behind the sign) unidentified, Carl Bennett, Burke Whitney, and Rodeo jeweler Al Micheli; (under the sign) Harry Canett and B. K. Shedd; (in doorway) Winston Smith; (outside the truck) Ed Sacca, Glen Ross, unidentified, and George Bonovich. (Courtesy Edward Sacca.)

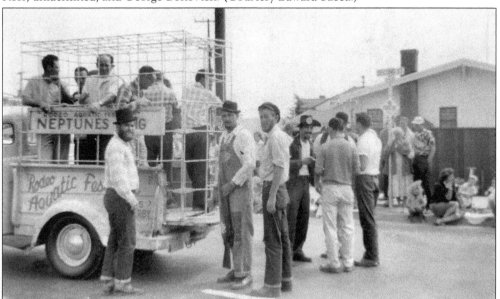

AQUATIC FESTIVAL. A full load of "prisoners" has been locked up in Neptune's Brig, which is stopped at Second Street and Pacific Avenue. The onlookers identified are Jim Salmon in overalls, and to the right are Jack Loftus in the Greek fisherman's hat and Ed Sacca in the hat with the button on the brim. (Courtesy George Serpa.)

123

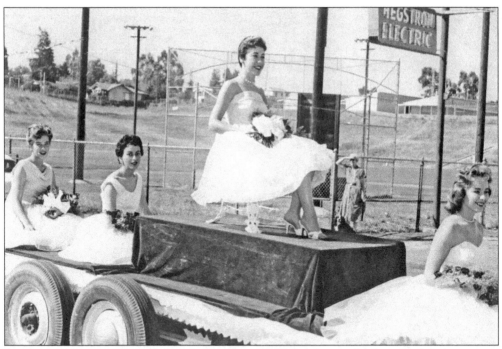

AQUATIC FESTIVAL, 1959. Departing Garretson Field for the parade down Parker Avenue are the 1959 Aquatic Festival queen Deanna Faria (at center) and her court (left to right) Sandy Crawford, Carmen Sacco, and Gayla Rogers. (Courtesy Jim Brownlee.)

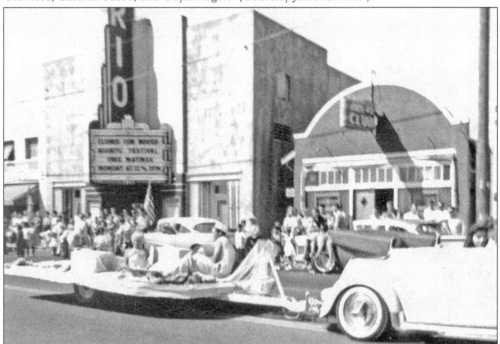

PARADE, 1959. The parade passes the Rio Theatre (offering a free program in celebration of the festival) and the Highway 40 Club, a "storied" building well remembered for the bank of motorcycles often parked out front. (Courtesy Frank and Sheri Silva.)

AQUATIC FESTIVAL, 1960. Official hostesses for the June 1960 Aquatic Festival included, from left to right, Donna Peck, Marsha Bonovich, and Silvia Smith. A 75-mile speedboat marathon up the Napa River and a water-ski race were aquatic festival highlights. (Courtesy Calvin R. Mower estate.)

PARADE, 1960. The unicycle drill team of the Children's Club of Concord performs a routine on Parker Avenue opposite the Dairee Maid restaurant. Rodeo's 1960 Aquatic Festival was sponsored by Rodeo civic and fraternal organizations, unions, and business firms. The 1960 parade included 112 units from as far away as Mountain View, Sacramento, and Napa. (Courtesy Calvin R. Mower estate.)

BENNETT'S MARINA, 1958. Carl Bennett, who took over the Rodeo Marina in 1957, said that at the peak, they were launching 150 boats a day. People came because the fishing was so good. (Courtesy Calvin R. Mower estate.)

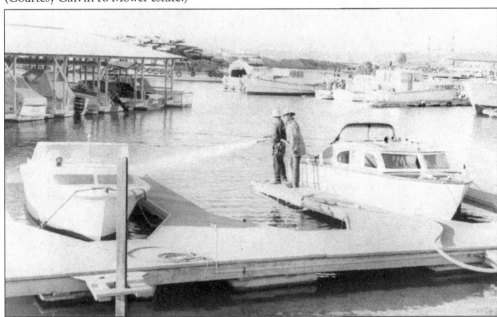

BENNETT'S MARINA, 1970. The Rodeo Marina was expanded to include 108 berths. This photograph was made around the time that activity began to decline, according to Bennett due to a lack of dredging, as well as diversion of the bay's fresh water and with it a drop in the fish population. (Courtesy Rodeo-Hercules Fire Protection District.)

FOR DEEP WATER LAUNCHING
RODEO MARINA
WATER SKIING

The NEW RODEO MARINA is a completely planned operation. The clearing of beach area for "take-off" when water-skiing together with the dredging of the channel has worked out as planned. Boat launchers and water-skiers in no way interfere with each other.

BRING YOUR FAMILY TO
RODEO MARINA
NO FINER BOAT LAUNCHING
IN WEST CONTRA COSTA COUNTY
--2 LAUNCHING RAMPS--
FOR FISHING . . . SKIING . . .
CRUISING AND PLEASURE

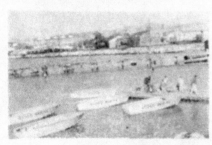

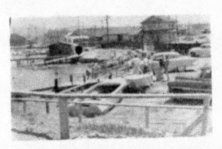

Boats For Rent--New Evinrde Motors
All New 16' Rockholt Boats for Rent

CARL
BENNETT
RODEO MARINA
TURN RIGHT OVER SP BRIDGE -- RODEO, CALIFORNIA PHONE 2602

BENNETT'S MARINA ADVERTISEMENT, 1958. This advertisement from the 1958 Aquatic Festival program says it all: boating, waterskiing, and fishing. To those with dreams of restoring Rodeo's vitality, the marina—once called Rodeo's "big blue front yard"—has the potential to become a destination once again. (Courtesy Dave Bunyard.)

Visit us at
arcadiapublishing.com

CPSIA information can be obtained
at www.ICGtesting.com
Printed in the USA
LVHW101458010321
680269LV00005B/196

9 781531 629038